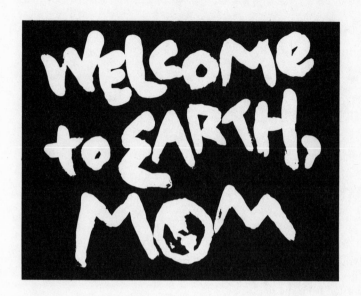

WELCOME to EARTH, MOM

by

ADAIR LARA

CHRONICLE BOOKS · SAN FRANCISCO

Printed in the United States of America

Library of Congress Cataloging in Publication Data

Lara, Adair.
 Welcome to earth, mom / by Adair Lara.
 p. cm.
 ISBN 0-8118-0090-3
 1. Mothers–United States–Anecdotes. 2. Motherhood–United
 States–Anecdotes. I. Title.
 HQ759.L37 1992 91-26447
 306.874'3–dc20 CIP

Book and cover design: Linda Herman + Company
Composition: T:H Typecast, Inc.
Cover Calligraphy: Jane Dill

Distributed in Canada by Raincoast Books
112 East Third Avenue, Vancouver, B.C. V5T 1C8

10 9 8 7 6 5 4 3 2 1

Chronicle Books
275 Fifth Street
San Francisco, CA 94103

▼ ▼ ▼

Table of Contents

▼ ▼ ▼

Introduction

This is a collection of personal columns. It's about my life, my children, my mother and father, my twin, my ex-husband, my boyfriends.

It's about operating a tricky clutch, dyeing my hair, raising the kids, being a single mom, reading the news, owning a cat, falling in love, getting mad, being Irish, watching movies, missing people when they go away, wishing it would rain. Most were written after I began a column for the *San Francisco Chronicle*; a number are from before that, when I was working as a magazine editor and selling an occasional piece to the Sunday paper.

A collection like this doesn't really need an introduction, but as it isn't arranged chronologically, it might be helpful to introduce some of the people you meet in these pages.

Very briefly, there are my children, Patrick and Morgan, born in 1980 and 1978, and their father, Jim, whom I share them with. We were actually living next door to him when the column began. There's my family, my mother, father, four sisters and two brothers. Mother lives in Marin County, just north of San Francisco. My father, now past 70, lives wherever the road takes him. He says I can write whatever I like about him. "Just get it all," he says.

The first boyfriend mentioned is Nick, the man I lived with for eight months in 1988, and then there's Neil, a magazine editor I was seeing when the column began. The last of course is Bill. It was when my boss made me put Bill's marriage proposal in the paper, giving the readers a proper introduction to him when I was just going to start mentioning him in passing, that I realized that I was

really writing a column about my life. I seem to get away with it, perhaps because, as Jung said, "That which is most personal is most common."

And I get away with it because of the patience and forbearance of all the people above, who've been remarkably understanding about being dragged into print, and because I've had help and support every step of the way.

I'd like to thank all of them, and some others: Peter Sussman, editor of *The Chronicle* Sunday Punch, who published those early pieces, and Rosalie Wright of *The Chronicle*, who kept reading them and eventually gave me a column. She wouldn't even listen when I wanted to have a back-up plan for when it proved a dismal failure. "It won't fail," she said equably. I am grateful to my editor at Chronicle Books, Annie Barrows, who put this collection together.

I want to thank Sinclair Crockett, a friend from the beginning, who always read my stuff for me, telling me it was awful when I thought it was great, telling me it was great when I was embarrassed she was even reading it. I have learned more from her intelligent reactions than from anything else, and I am forever grateful.

I want to thank all those who have written to me since the column began. Those letters make me happy. They give me heart. "Go ahead, spill the beans," they say. "We've been there too, and we're behind you. We're here, listening."

Finally I want to thank Bill LeBlond. He not only lets me print whatever I like about him, but offers sage advice on every column I write. Living with an editor might for some writers be sleeping with the enemy, but at our house it works out.

THE KIDS

▾ ▾ ▾

"There is nothing like impending parenthood to fill one with the most magnificent plans. And nothing quite like the arrival of the actual baby to puncture them."

▼ ▼ ▼

Perfect Parenthood—or Bust

T here is nothing like impending parenthood to fill one with the most magnificent plans. And nothing quite like the arrival of the actual baby to puncture them.

When I became pregnant for the first time, my husband, Jim, and I read all the current baby literature and made our plans. The children would be breast-fed. We would supplement their education with home tutoring. Sugar, gum and soda would not pass their lips. Our home would be filled with cultural excitement of every sort, from stimulating conversation to rooms of books to "Masterpiece Theatre."

Then the kids were born, putting an end to this nonsense. Morgan was first. She made it plain that she found the whole nursing business claustrophobic. I would settle in my rocker with the usual tremendous sense of self-congratulation, and she would keep breaking away to see whether anybody interesting had come into the room. What to me was an intimate moment of sharing was to her a blocked view, an annoying highrise that had sprung up unceremoniously on her street.

At the end of six months I gave her a bottle. She seized it, swung it up in the air, and leaned so far away from me that she was practically hanging from my lap. As she drank, she gave me a look that said, "This was available all along and you never told me?"

The Irish in her must have kicked in, because she was 11, 12, 13 months old and still hitting the bottle as if her happiness lay at the bottom of it. And I was still getting up at night to change her diaper, sleeper and blankets, and all but wring out her mattress.

If there had been a hotel for babies I would have called her a cab.

Eighteen months after Morgan was born, Patrick came along. I was by this time weary of playing Earth Mother and about ready to kill for a drink, so I switched him to a bottle, or tried to, when he was 3 months old. Again I had miscalculated: This little guy would happily have nursed until his wedding day. I couldn't get him to like his bottle even after giving him the enticing choice of it or starvation.

This went on for months—Morgan hanging on to the bottle for dear life, Patrick throwing touchdown passes from his crib with his— while we stood helplessly by, clutching our useless baby books. They finally resolved it without our help: One day Morgan crept up alongside the crib and swiped Patrick's bottle. He cried and got picked up, and they were both happy.

Now the kids are 9 and 10. They eat a cereal called Morning Funnies and watch sit-coms supplemented by that fine old art film, "Police Academy 6." The only instrument they can play is the radio, and the hours I had envisioned myself bending over their homework have dwindled, all too often, to my saying in the rushed morning, when Patrick has forgotten to do his arithmetic, "So you'll do it tonight, OK? I'll write you a note."

We have discovered that they are, after all, ordinary children, and we are ordinary parents—frail and forgetful and likely to switch on the TV when we're tired. They are not the paragons of our loins, the culmination of all that we could wish for them and for us. They are simply Morgan and Patrick, growing up not in our dreams but under our noses, and, for good or ill, in our images.

This morning Morgan made her brother and me a surprise breakfast of eggs fried inside slices of hollowed-out French bread. We had been admiring this recipe in "Moonstruck" the night before, as we huddled in front of the VCR instead of poring over the world map or traipsing out to identify the local flora.

They weren't bad.

▼ ▼ ▼

I Knew All about Childbirth, Having Been Through It One Whole Time

The day of my son's birth was a brilliantly sunny Saturday. Everybody was bustling about in a very annoying way, plumping pillows, chattering away about centimeters of dilation and how strong the baby's heartbeat sounded. Nobody seemed to have any interest in my heartbeat, and nobody, but nobody, was getting the picture here. I was not having a good time.

Just as I was about to bring this up, I was wracked by a pain so great that it felt as if a giant were squeezing me out like a sponge. "Little twinge, hmmm?" said Dr. Warner, absently. He was making one of his infrequent appearances at my bedside, in between listening to the football game on an office radio. I had arrived at 9 in the morning, and it was now 11.

What was I doing here anyway? I wasn't the kind of person someone would hand a baby to. I always was the one who stepped high over the tots on my way to the drink table.

I was, in short, cut out to be a maiden aunt, someone who arrives from some exotic junket in a cloud of perfume, carrying armfuls of presents and having to take a wild stab at the names of her nieces and nephews.

How a glamorous maiden aunt had come to be lying for the second time in a badly decorated room in the alternative birth center was an old story—you meet a guy, you like the cut of his jib, and bang, you're a pawn in nature's scheme to cover every inch of the Earth with humans.

The first time around, I was into the birthing experience. I walked for miles every day, attended childbirth classes, made long

lists of names. When Morgan was born, "Chorus Line" was playing on the stereo and I was 17 points ahead in Scrabble. I was sure that only professional ethics kept the doctor from commenting on Morgan's unearthly beauty and the intelligent glint in her eye.

This time I had done nothing. I had heard that second births were easy—you practically just dropped by the hospital and picked up your baby. Besides, I knew all about childbirth, having been through it one whole time. I skipped the walking and left the birth books on the shelf. I even had the occasional glass of wine, though I couldn't help visualizing the baby swinging tipsily from lamp shades in the womb when I did.

I also had forgotten the pain, but that first contraction has a way of bringing it all back to you. While I was hanging half on and half off the bed, with my nose touching the floor—the only position I felt comfortable in—the giant hand squeezed again. I was supposed to be doing my Lamaze panting, of course, but I had forgotten how.

All similarities between us and those happy Lamaze mommies in the birthing pamphlets had disappeared long ago. Lamaze couples racewalk to the hospital after a hearty granola and yogurt breakfast, do their rapid breathing number while reading poetry to one another and the select few dozen friends they've invited to watch the birth, and 10 fun-filled minutes later notice the arrival of a rosy, fit and alert Lamaze infant, ready to be fitted into a backpack and borne off to a Save the Whales march.

As for me, I was going to give the doctor one more chance to give me drugs, and then I was going to try to get somebody with real connections, like a screenwriter.

Dr. Warner loomed up, six feet of starched unconcern. His every movement said, "This is a man who wants to get back to the game."

"Pain killers?" he said, looking at me as if trying to remember what they were. "They would only relax you between contractions, and you already look relaxed."

I looked relaxed? How would I look if I were in pain?

"You said," I ground out between one of my relaxing contractions, "that you would give me something if I asked for it."

"Believe me," he said, fastidiously flicking my sweat off his sleeve, "you don't need it."

I waved him away. This man could whistle for his fee.

The actual moment of birth is moving. You take off all your clothes—this is after nine months of eating enough not for two, but for a small country—assume the most unflattering position imaginable, and do what the books euphemistically call "bearing down."

"It's a boy!"

A boy? A boy? Oh God, I wanted a boy.

My baby was the color of a plum and the size of a small van. My husband, Jim, his hand trembling in a way that alarmed even blasé Dr. Warner, scissored carefully through the cord. "Come meet your mom," he said through tears, and settled the baby in the crook of my arm before kissing us both.

The doctor said, "I want to be here when they weigh that sucker," and went back to the game. Jim rushed off to call his 90 relatives in the Midwest with the news.

Then it was just me and the baby, with the May sunlight streaming in on us both. He lolled on my arm, all, as it turned out, 9 pounds 14 ounces of him, and stared very seriously at me with dark blue eyes. He was gradually becoming a softer decorator color, more of a mauve. On him it looked good.

I couldn't take my eyes off him. Feeling only a little silly, I told him who he was, and how fast I was falling for him, and that he had an 18-month-old sister at home who was probably at that very moment working out a way to make his death look accidental.

I decided it would be all too easy to spoil him.

"So," I said, just before we both nodded off. "When are you planning to get a job?"

▾ ▾ ▾

There's No Time
Like the First Time

W ell, it was bound to happen. My only son asked a girl over
yesterday for the very first time. I had heard a lot about her—
Oona this, Oona that—and then the doorbell rang and there she
was, standing mute on my doorstep. What could I do? I asked her in.

She was pretty enough, I suppose, with her big brown eyes and
long brown hair, tangled in a way that suggested she could attract
boys without any overzealous attention to toilette. But where had
she been when I was tucking him in at night, finding his stuffed
brontosaurus behind the couch, teaching him to step into his swing?
Had I done all that just to lose him to the first skirt to come his way?

Of course, I knew what Patrick saw in her. He didn't want to
tell me, but I coaxed it out of him one night over cups of hot choco-
late: She can snap her toes better than anybody else in the second
grade.

A cheap accomplishment, you say. But yours is not the heart of
a 6-year-old boy. To him, a really gifted toe snapper is right up there
with the angels. This is it for him.

I know it is, because I have plumbed the depths of his *affaires du
coeur* before. Last year, in kindergarten, he met a girl who never went
outside the lines when she colored. This absolutely floored him, and
he Scotch-taped her drawings to his bedroom wall.

That blew over harmlessly enough before anything could come
of it—she was transferred out—but Oona was different. For the half
hour before her arrival, he simply sat on the couch, arms tightly
folded at his sides. He was just waiting.

When she arrived, the toe snapper, Patrick, Morgan and I took an assortment of balls and went over to the local junior high. It was Sunday, the sun was shining, Patrick's hopes were high. It had taken him since Christmas break just to get her phone number, and then he had lost more time dialing wrong numbers, but he had persisted and now she was here. She had come to his house!—and therefore could no longer be regarded as totally impervious to his charms.

That was at noon. By 1 o'clock, after the egg salad sandwiches and grocery store sodas, she had torn his heart to bits. She played only with his sister, she refused a ride on his skateboard, she didn't even look his way when he proposed a game of toss. Patrick hunched at my side on the playground all afternoon, 58 pounds of sheer male misery.

I could feel no sense of triumph as I helped him blow his nose, brushed the blond hair back from his brow. Love had brought him only pain.

I said, "She's shy and only knows how to play with girls." He said, bitterly, that he wished he were a girl, then. I whispered back that I didn't think that was the answer.

In time, he'll get over it. It might take an hour, but life's joys —the warmth of the sun on his face, the solid thump of a rubber ball against our neighbor's wall—will once more have meaning. There will be other Oonas—some hussy who knows the multiplication tables by heart, another whose handwriting is heartbreakingly symmetrical.

Never again, though, will it be the first time. Never again will he give his heart as freely. Oona is gone now—she just blithely skipped off to her piano lesson. She will never know what she has done.

▼ ▼ ▼

Message to a Child:
"You Don't Deserve This"

I have been trying to tell the story of the day Morgan finally got on the honor roll, and then tore the certificate into pieces.

Morgan is in the fifth grade. She is not the best-behaved student at her school. She talks in class, she tries to convince me that her pockets are stuffed with candy wrappers because she picks up after the other kids, and she whips off her sweat shirt to reveal a halter top the minute the yard teacher turns her back. When her second-grade teacher retired at the end of the year, I had to be reassured that Morgan had nothing to do with his decision.

She also runs with a sometimes irritating gang of other pretty, popular girls—Susan, Leah, Jackie and Bonnie. Tiny Jackie is always armed against rejection with candy that she buys with money from her father, who is Filipino and eager to please this diminutive, demanding little American he has fathered. Bonnie is tall, with the gawkiness you know will be beauty in another three years, while quiet, polite Susan is at her best now, with the pug features and mop of frizzy hair that look best on children. Morgan is the youngest. She is given to sweeping her blond hair rakishly over one merry eye, ending up with an effect somewhere between Gina Lollobrigida and a sheepdog.

Their leader is Leah, a pint-sized blond bombshell who rules the others with an iron hand. "What's so big about that?" she says to practically anything the others say, and they fall silent, admiring how their petty boasts are blasted by the Queen of Cool. Morgan will refuse to wear a pair of jeans that Leah has declared to be uncool. "Mom, Leah hates those jeans. They don't fit right! She'll tease me,

I don't have any other friends. I'll have to walk around at recess by myself for *two days*."

Most of the gang makes the honor roll every time. "We're all sort of the same smart," Morgan once explained to me, "but Susan's the most intellectual." Morgan has been doing everything she could to make it since kindergarten—sometimes even her homework—but without much luck, as it is based to some degree on deportment.

When it finally happened, she called me up at work to tell me, very off-handedly, working it into a running account of her day. "Oh, yeah, and I made the honor roll, Mom." There was talk of a trip to Esprit.

She didn't call me, two days later, when she tore up the certificate.

On that day, Leah and Morgan decided to put fake love notes in all the kids' desks during recess. This was a terrible prank, and I still regret that I burst out laughing when Morgan told me about it.

Morgan was caught, two hours before the assembly at which the honor roll certificates were to be handed out. The whole school rocked with the news that Morgan had been "busted" and refused to finger Leah.

"You don't deserve this award," the principal told her, after Morgan walked all the way up to the front of the assembled fourth and fifth grades and was stretching out her hand for it. "You only made it by the skin of your teeth, and you don't deserve it."

Morgan kept her eyes downcast—she told me later that's what they expect you to do when you are being lectured—and waited until she got back to the classroom to tear the certificate to pieces. We knew nothing about it until Morgan burst into tears in the middle of dinner at her dad's house that night. Jim found the pieces of certificate wadded up in her jacket pocket, jumbled among the candy wrappers and the headband she refuses to keep on.

"I didn't deserve it," she told him. "Please don't say anything to the principal. I'm in enough trouble already."

Jim called me minutes later to tell me the story. Usually an estranged couple who spend no more than 10 minutes a day together, exchanging kids, we were one again, a honed and danger-

ous parental principal-seeking missile aimed at the heart of Morgan's school.

An hour later we were perched on the edge of a couch in the principal's office, still in our jackets, as if we were the ones with something to answer for. The principal sat on her hard brown chair at her desk surrounded by papers and charts and thumbtacked pictures of children. She is a rather handsome woman of about 40 who strides around the blacktop chatting with the yard teachers and keeping a weather eye out for halter tops.

"The kids were very upset by those notes," she said, as if that were the end of it. We had been talking for 10 minutes and were getting nowhere. She was bent on viewing the incident as upon the whole a useful lesson.

"And what am I supposed to do with this?" Jim shook the pieces of the certificate out of an envelope. His voice trembled. "Just throw it away?" The two of us stared at the pile of torn paper on the edge of the desk. One of the pieces fell on the floor, and Jim and I both bent forward to pick it up.

The principal barely glanced at them. "No, I wouldn't throw them away. I'd tape them together and put them in her scrapbook so that she can learn a lesson from this experience," she said. I stared at her. This woman was not getting it.

Finally Jim asked her to apologize to Morgan, and she said she would, and later she did, though I bet she slipped in a little, "Now, Morgan, remember that if you hadn't . . . " We Scotch-taped the certificate together and put it on her dad's refrigerator, where it remains.

It was not a huge incident. It was just a thoughtless remark, made in public, that a child might remember. That she might carry with her into adulthood, like torn-up bits of paper in the pocket of an old pair of jeans.

Getting My Way
at the Movie Store

"**W**hy don't you choose the movie this time?" Patrick said to me Saturday night, after the kids and Neil and I had taken our usual bracing two-block hike to the Video Room.

Me? Choose the movie? I looked around to see whom else he might be talking to. The three of them had peeled off to the bulging racks marked "Newly Arrived Schlock Films for Boyfriends and Kids," and I was waiting to see whether we'd be renting "The Naked Gun" for the fifth time or "Real Genius" for the ninth.

"It's your turn," Patrick continued. Morgan and Neil nodded. I looked at them all suspiciously. What was the catch?

I had been hovering forlornly in my own section, which is the one marked (in my desolate imagination) "Sensitive Films No One Would Go See With You." This section is crowded with women ecstatically filling their arms with "Ironweed," "Manon of the Spring," and "The Music Teacher," only to put them back tearfully when they noticed the fine print: "And That Nobody Will Sit Through With You in a Million Years at Home, Either."

In the past spring, I've seen "Joe vs. the Volcano," "Teenage Mutant Ninja Turtles," "Crybaby," "Tremors," "The Little Mermaid" and "Miami Blues." Although I feel enriched by the subtle themes explored in these films, I really want to see "Driving Miss Daisy," "Steel Magnolias," "Cinema Paradiso" and "My Left Foot."

The kids aren't so bad—Morgan offered to come see what she called "Sex Lives on Videotape" with me—but I suspect that my boyfriend, Neil, reads reviews only to avoid movies that get good

ones. If a critic calls a movie "sensitive" or "uplifting," he decides it's a "women's picture" and refuses to go see it.

I haven't seen a "women's picture" since "Menstruation and You" back in sixth grade, but I know everybody wants something different from the movies. I like films about real life, or at least a Hollywood concept of real life.

He wants escape. He doesn't want to be educated, enlightened or roused to action by the movies — he wants a rest from all that. And he looks forward even less to fidgeting through some epic "Scenes from a Relationship" that reminds him uncomfortably of the two of us sitting down for one of our talks. He likes to be taken out of himself, to see pretty people and laugh at stupid jokes.

In short, he wants to see "Airplane" again.

I could go to the movies alone, but even "Menstruation and You" was more fun in company. So when Patrick's offer came, I grabbed "The Accidental Tourist" and hurried everybody up the street before they could change their minds.

Back home, the kids and Neil buried themselves under fuzzy blankets and shushed one another elaborately: "Let Mom watch her movie!"

In silence, we watched William Hurt fill a suitcase while reading a list of what to bring on a business trip. He put in a book, underwear, socks. He seemed depressed, though it turned out this was a moment of frenzied abandon compared with his demeanor for the rest of the flick.

"Do you like this movie, Mom?" Morgan said hopefully, with her head in her hand, respecting my need to watch the most tedious film ever made.

Then Patrick lost it. "Wrestle!" he yelled, and dragged Neil to the floor. Morgan piled on top, and all three of them missed this great shot of Hurt putting a spare pair of boxer shorts in the suitcase.

Clearly, they have no idea how to have a good time at the movies.

School Daze in San Francisco

D on't tell Patrick's teacher, but he wasn't sick the other day. We were at the beach. He said he had a stomachache, and I could see he had something—maybe not a stomachache, but some affliction as great—that prevented him from contemplating school that morning.

It might have been the giddy winter sun cartwheeling in through the glass patio door. We couldn't see the clock in all that sparkle, let alone Patrick's schoolbooks. In any case, the sun would hear nothing of math tests or column deadlines. It found our jackets, locked up the house, thrust my car keys into my hand.

It didn't stop pushing until we were plunked down on the warm sand at this secret beach I know, called, in a wild burst of someone's imagination, Ocean Beach. It's kind of a shifty expanse, but it's the perfect place to be on a weekday, especially when you're a kid who needs a day off.

Patrick has been trying manfully to settle into his new school. He gets up at 7, slowly buttons his white uniform shirt and takes the J Church streetcar to a Catholic school across town.

We're not Catholic. We just needed a new school, fast.

Patrick's public school in the Castro was just fine until the good teachers started leaving, most of them in selfish pursuit of a livable income. Five left last year alone.

Last September Patrick got one of the replacements. All the children in his fourth-grade class were coming home more sullen, less enlightened and considerably less confident than when we sent them off.

The parents were up in arms. We had meetings in which we sat on tiny chairs and waved our arms around. Several parents took their kids out of the school. Several others slipped away from work each week to spend time in the classroom, trying to turn it into a place where their kids could learn something.

I went once. "I didn't see you raise your hand. We raise our hands in this classroom," the teacher told a child, frostily. She didn't go on to ask him what his question was.

Patrick was learning something, all right. "I'm not as smart as I was last year," he told me, sulking over his snow leopard report, showing no signs of caring whether this animal is found in the mountain fastnesses of Asia or on the slopes of Telegraph Hill.

Halfway through the year, we gave up trying to make that school work. Patrick's friend Edward transferred out with him, though Frances, his mother, had gone to that school herself as a child, and was pained to have to leave it.

I know it's childish of me to blame the teacher. It's the whole San Francisco Public School District, which is run like a MASH unit performing academic triage. There just isn't any money.

Unlike some, Patrick's dad and I have choices. Private institutions abound in San Francisco, and I hear the schools in Albany and Palo Alto are the best in the Bay Area. I could vote with my feet, the way so many already have.

But I don't think I can help the public schools by moving to Albany. Besides, I don't feel like it. I'm a fifth-generation San Franciscan. My parents met on this beach in 1946. Rather than leaving or searching for a private solution, I wish we could all find a way to put the public back in public schools.

By the time the sun let Patrick and me drive past the cypresses and the windmill back toward long division and grocery shopping, the day was pretty much gone. There'll be hell for him to pay in class, I guess. Playing hooky from school—or from the schools—isn't much of a solution.

Is Popularity
a Pact with the Devil?

I was walking down Castro Street when I spotted Morgan in the Double Rainbow ice cream shop with a group of other girls. She was laughing, her blond head tilted back.

When I knocked on the glass, she came spilling out, followed by her friends. "This is my mom," she said proudly, with a gesture that took in the black jeans and leather jacket I was wearing. "Didn't I tell you she was cool?"

As the girls clustered around me, I felt an old, familiar pang. If, by some miracle of time travel, Morgan and I were in the sixth grade together, I'm not sure we would be friends. Although she would vigorously deny it, she's one of the popular girls, the pretty, hair-tossing ones. The kind I was forced to despise, because I was not one of them.

It wasn't that I was fat in the sixth grade, like the Nevelson twins, or skinny, like Sara Hendricks, whose dress hung on her as if it were still on the clothesline. I wasn't freckled or dumpy or hide-ous. I just wasn't particularly cute.

The best that I can hope for actually, looking back, is that I was one of those girls Mick LaSalle meant when he wrote about the "tall, quiet and slightly odd girl in school, who sat in the back of the class-room and occasionally got off a witty line about the teacher. But nobody knew her really well, and it's only now that we're older that it dawns on us that she was interesting."

It doesn't matter that this dawning takes so long, because being interesting is not going to get you anywhere in the sixth grade.

What matters is being cute. Cute kids hang out with other cute kids, so chances are Morgan and I would not have hung out together. As I lingered near her group, hoping to be invited to tag along, I might even have resented her.

It wasn't fair for her to have that cascade of blond hair and those green-flecked eyes, and to have so many friends while I paced the playground alone.

It wasn't fair—unless she had traded something for them. Popularity, I figured as I sat alone on the bench with my books, had to involve a pact with the devil. You swapped away things that got you nowhere in grammar school—brains, charm, sensitivity, being interesting—in return for those that did.

Looks.

At my school the prettiest girl was Mavis, who got breasts earlier than anyone else, and had to remind even a nobody like me of that fact by crushing me to her chest at every opportunity.

She went out with a handsome green-eyed Russian immigrant kid named Alex Askinov, while I hung around with a weird red-haired kid named Billy, whom I didn't even like very much.

I used to fantasize about running into Mavis in a drugstore when we were grown up. In this daydream, she is fat, with lank, unwashed hair, those precocious breasts sliding inexorably south.

I, on the other hand, have blossomed unbelievably, acquiring blue eyes and high cheekbones, and have dropped by the store to buy a frame for my Pulitzer Prize.

However, now that I am clothing and sheltering a Mavis in my own home, I realize that Mavis probably wasn't so bad. She wasn't shallower, or stupider or less sensitive than anybody else.

My pet theory that good-looking people must pay for their good fortune with brain cell leakage has collapsed. My new theory is that good looks build character, as there is so much more temptation to overcome.

▼ ▼ ▼

Looking for Fun
in All the Wrong Places

I t's time to start thinking about what the kids and I should do on
vacation this year.

Last year, I put everything I had into this, our one uninter-
rupted time together all year. As a working mom, I had missed
enough–Morgan's gymnastics final, the shoe Patrick had had eaten
off in an escalator accident, his double with the bases loaded–to
want it to count for a lot.

I saw the three of us sunburnt and laughing–on the beach, on
a roller coaster, zipping along Highway 1 with the sunroof open to
catch the Pacific breeze and Bobby Brown wailing on the stereo. I
wanted to compress a lifetime's memories into a single week, the way
Morgan, then 10, tried to get her whole wardrobe into one suitcase
–just cram them in, and sit on them and lock them safely inside.

Our plan was to head for Disneyland with stops along the way.
It was agreed that I would drive, Morgan would be in charge of tapes
and Patrick would remind us to put on our seat belts. We were going
to have more fun than a mom and two kids had ever had.

But it kept going wrong. When we got to the Santa Cruz board-
walk on the first morning, it was cold and foggy and Patrick, shoving
his hands into his pockets, wanted to call his dad to see if he was still
OK since we had left him two hours before. Morgan was biting her
lip because we were just standing around when we could just as well
be looking in the shops.

And so it went. Hearst Castle was closed when we got there. At
Venice Beach, people were hanging around the parking lot and we

worried about leaving the car. We went to the zoo, to the water slides, to Universal Studios and finally to Disneyland, which was a nightmare. While we were resting from standing in line, a sanitized pop group rose out of the concrete in Tomorrowland, sang a sanitized pop tune and sank back into the ground while we chewed our hot dogs. Finally we just sat on a bench, having a contest to see who could spot the ugliest pair of shorts.

We felt like failures. What was the matter with us, that we couldn't even have fun at Disneyland?

The kids did their best to pretend they were having a good time. I can remember doing that, too, when I was little and we were camping on the hot, flat banks of the Sacramento River. The other kids and I were sunburnt, paddling listlessly in the water and wishing we were home when something in my father's eye said very clearly, "We brought you all this way to have fun. Now start having it!"

About two-thirds of the way into the week, we admitted the vacation was a disaster. I stopped listening to Bobby Brown and put a tape of Russell Baker's "Growing Up" on the stereo. Patrick called his dad and blurted out how much he missed him. After hours in line, Morgan said, "I know you paid a lot to get us into Disneyland, Mom, but can we please just get out of here and go swimming?"

So we did. Just passing through the gates cheered us up. We found a pink motel with a pool right down the street from the park, carried our bags in and emptied them all over the room, which was too Disneyland-neat for our tastes. We swam in the pool, ignored an old woman in the spa who pointed sternly to the "Must be 18" sign, used every towel, and then went roller skating on the smooth tops of the storage tanks at the gas station next door.

It wasn't until I got home that I remembered that one of my best memories—my mother cantering down a beach, singing "Ride a Cock Horse" while I clung joyously to her back—happened during that hot camping trip on the Sacramento River. Like fun—I'm learning—good memories happen when you stop trying so hard to have them.

▼ ▼ ▼

Mom Gets Cold Feet at the Rink

There's an ice-skating rink out on 48th Avenue, near the ocean. It's been there forever, on a quiet street in a residential neighborhood, but school kids have lately rediscovered it as a place to see and be seen, especially during Christmas vacation.

My kids, who at 9 and 11 realize they have to find partners pretty soon, before their looks go, begged me to take them.

And they wanted me to skate, too. "You never play with us, Mom," Patrick grouched. "You're always reading."

"I am not," I said absently, looking up from my page.

Always reading, indeed. No one was going to accuse me of setting that kind of example for my kids. I'd show them.

So I had never ice-skated before. How hard could it be?

The rink is a huge icy barn of a room, with faded snow scenes on the brick walls and "skate at your own risk" signs everywhere.

Patrick charged right out and had already been around once when Morgan was still trying to pry my hands off the railing.

"It's easy, Mom," she said. "Watch this." And then she, too, was a blur in the circling throng.

Left to myself, I watched the crowd of kids for hints. They careened around corners, deliberately crashed into one another, spun around in circles and tried going backward before they knew how to go forward. When they wanted to stop, they just slammed full speed into the nearest wall, then got up and kind of reassembled themselves, like the evil Toon in "Who Framed Roger Rabbit?"

It was like trying to get exercise tips from a bunch of rag dolls.

Besides, as you get older you kind of lose that falling-down, picking-yourself-up-and-trying-again stuff. You get into falling down and staying there, waiting for the paramedics.

My plan was to go very, very slowly. I would not fall at all. As I let go of the railing and started out, my fragile 37-year-old knees wobbled, my ankles were Jell-O, and I was dimly aware of a fleet of toddlers streaking smugly past my knees, their tiny skates flashing, their bottoms damp. But I didn't fall. I was cool.

After a half-hour or so, the kids led me to the log cabin snack bar. While I was there, fighting with some sodden tots for space at the stand-up heater, I overheard Patrick tell Morgan there was a girl he wanted to meet.

While Morgan dived into the throng, I scanned the roomful of schoolgirls for someone good enough for my only son. There was no one.

Then Morgan reappeared, dragging a little girl wearing a long black T-shirt who seemed determined to look anywhere but at Patrick.

"She says she might like you, but she isn't sure," Morgan whispered in Patrick's left ear.

"Why don't you talk to her yourself?" I whispered in his right ear.

"Oh, Mom," he said, dismayed to find that he not only still had a mother but also that she was hovering at his elbow, listening eagerly. "You have to go away. This is kids' business."

OK, fine. I'm not one of your suffocating moms. With a great show of picking up my purse and coat and newspaper, I got up and moved about six inches away. I sat down again, very inconspicuously, and buried myself in the classified ads.

"Mom."

"Ummm?" I said, looking up with an air of abstraction.

"You have to go farther away. Maybe you could go out to the car and read your book."

All the Newts Fit to Print

Until last week Patrick had six fire-bellied newts living in a tank in his room. He loved those newts. He fed them, changed their water, fretted when they seemed to be spending too much time staring into the middle distance.

He is a trusting kid. He held nothing back, no little part of himself that measured how much love it is safe to mete out to a newt.

At first I didn't worry about this because these creatures, according to Robert Benchley, author of "Social Life of the Newt," have an extremely happy home life.

Maybe *his* newts did.

One day one of ours was missing a leg, and then a tail. It worried Patrick, though Cliff at the East Bay Vivarium assured me the loss of a limb is common, as the leg of one newt tends to look like lunch to another. "They get quite used to losing them," he said cheerfully.

They may get used to it, but it kind of disturbed me. I decided to get some more newts and keep them in the basement, to switch them if one of Patrick's died. "Hallelujah! It's a miracle! It just woke up!"

They were all out at the newt store, but it started to look as if we would soon be awash in them anyway. I had read Benchley's description of courtship in the newt world, where the male woos the female with a dance that he won't leave off even if you replace the object of his affections with an eraser. I hadn't seen this hoedown in

our tank, but there must have been one, because two of our newts turned up with a lot to explain.

Patrick was thrilled. Despite an embarrassing episode in which he and I mistook some bubbles for transparent newt eggs and tenderly transported them to safety in soup spoons, all went well in the next weeks. Patrick was laying in a supply of cigars. Each of you was going to get your own newt.

Then it happened. One day Patrick got up and as usual rushed to the tank to see if there were any eggs yet.

There weren't any eggs, and there wouldn't be. All the newts had died.

Patrick's grief was explosive, angry, rushing through him like a storm. He pounded the couch and ripped up a paperback I handed him for the purpose. He cried. Then he fished the newts one by one from the tank and carried them over to the rose bush for burial.

I was a little upset too, after worrying over the things for weeks. Feeling helpless, babbling something about how maybe they were older than we thought, I offered to get Patrick more.

"I don't want any more newts if they're going to die," he said.

We still don't know what went wrong. Maybe a virus . . .

"What do you mean, you don't know why they died?" exclaimed my friend Sinclair when I told her all this, over sandwiches at Sally's Deli. "You parboiled those newts by leaving them on the deck. Or weren't you going to mention that part?"

Actually, I wasn't. I did put them outside, on a cool, overcast day, after the vegetation Patrick put in for the egg-laying rotted and a rank odor crept through the house. When they seemed to like it out there, I thought with relief, "Great, they can live outside."

I went on thinking this as the days grew warmer.

I didn't mention this to Patrick as a possible explanation, and I hope you won't either, if you see him. It's enough to have learned the sorrow and risk of loving a mortal creature, without being tortured by what Mom did.

My Baby Wants to Be a Teenager

When I went to bed last night there was a rustling in my closet. I sneaked up with a baseball bat, to find Morgan, a tiny blond doppelganger, trying on my clothes. She wants to know whether my Guess? jeans can now be our Guess? jeans, because they fit her, sort of.

She'll be 12 this Sunday (not 13, as she has been telling everybody). She wants me to call her room her "apartment." When I took her swimming Saturday, instead of jumping into the pool, like the child she used to be, she stretched out on a deck chair, asking for a towel, sunglasses, sun lotion, and a radio.

With adolescence looming, she's experimenting with one of its most important tools, sarcasm. If I sing along to the radio, she says, "Don't give up the day job, Mom."

The other day I got off the phone and said to her, "Morgan, that was Grandma calling back."

"No kidding," she said, not looking at me, brushing right by.

"Come back here," I said. Then I came back out of my bedroom, saying pleasantly, "Morgan, that was Grandma calling back."

"Oh, cool, Mom," she said, brushing by me again.

We tried it one more time.

"Morgan, that was Grandma calling back."

"Oh, great, Mom," Morgan said, looking me straight in the eye and smiling. "What'd she say?"

She told me she can't take better care of her clothes because she lives in two houses (her dad lives next door).

"Are you telling me you throw your clothes on the floor because you come from a broken home?" I asked.

She grinned. "It was worth a try."

It was raining and I was 17 points ahead in Scrabble when she was born in Mount Zion's alternative birth center at 2:27 a.m. We didn't find out until later that Morgan means "born by the sea."

We hovered over her. If we went away for the weekend, I left five-page instructions that must have amused my baby-sitting mother no end, and her dad would already be reminiscing about her as we backed out of the driveway.

Later when she was a toddler refusing to eat her dinner, I would catch him sneaking downstairs later to feed her. "Well, she was hungry!" he would say when I confronted the two of them.

Now this baby wants to be a teenager, even though she just grew tall enough to reach the cereal without jumping on the sink. She wants a birthday party, with boys, at which I will be allowed to make brief appearances if I am wearing very cool clothes and don't embarrass her by dancing.

She's five feet tall and wears a shoe size a half size behind mine. I can't lift her—I think we all feel it, the kids and me, that I can't pick them up anymore. Year by year, I get weaker. Pretty soon it'll be time to leave me on the ice floe.

But they get stronger. "I can lift you now, Mom," Morgan said the other day. And, to my astonishment, carried me piggyback around the living room, staggering only a little under my birdlike weight. This sprite I once carried in my two hands.

At night she still falls asleep on the couch and has to be dragged, useless legs catching on everything, a smile on her supposedly sleeping face, down the hall to her apartment.

Mom the Chaperone
Should Be Invisible

W hen Morgan asked me to be one of the chaperones to escort the very talented Everett Middle School seventh- and eighth-grade chorus to Stonestown on the street car, I was ecstatic. I haven't been a chaperone since that little incident at the Exploratorium with Patrick's third-grade class, when I showed up back at the bus with 7 of the 10 kids left in my care. Even after I pointed out that I had returned well over 50 percent, the teacher seemed upset, and I wasn't asked back.

I was also happy Morgan asked me because ever since she turned twelve last month, we haven't been getting along as well.

The day after her birthday party, she and her friends were enjoying some rap music and a snack when I came home and started yelling about the noise and mess. Morgan said she'd just been about to turn the music down and clean the whole house when I walked in, and while we glared at each other her friends put on their jackets and were sympathetic, but they had mothers of their own to deal with.

It's the same for all the kids. They hit 12, and suddenly their parents start lying awake nights thinking up ways to annoy them.

I hear Morgan and her friends talking this over in low, worried voices. Rachel's mom can't even do her hair right any more, and Jessie's expects her to take out the garbage. As if Jessie were her *slave* or something. David's dad talks to other passengers on the Muni, and Morgan's dad—suffice it to say he was forbidden to come to the mall. "Dad will follow me around, and hug me, and say, 'Oh, honey, that was just wonderful.'"

▼ ▼ ▼

And Morgan's mom. Boy, has she changed. "You used to be so nice," she told me one day, almost in tears. "I liked hearing your voice in the afternoon telling me I could stay at Rachel's longer. My friends all thought you were the coolest mom. Now you're so *mean*. You yell all the time."

It's true. I get all bent out of shape over the littlest things now, sometimes yelling at her, sometimes begging her to return enough of my wardrobe so I can piece together an outfit for work. Even my once-endearing ways have begun to cloy. She says she used to like the way I say "soitenly" but now it's embarrassing; she wishes I would just say the word right.

The funny thing is, I know what it's like to turn 12 and have your mother all of a sudden flip out on you. When my own mother asked me to straighten up the living room, I naturally told her to go to hell, and she grounded me, *just for that.*

Kids like Morgan have nowhere to turn. We parents have our comforting manuals, like the one I've been clinging to lately. It says: "You can tell quite easily when your child has shifted from middle childhood to preadolescence because the child suddenly becomes obnoxious in every way you can think of." There's not a word on how to deal with Mom and Dad when they start behaving erratically.

All a kid can do, really, is hope the parents will grow out of it, and in the meantime choose their clothes for them, and try to get dropped at the corner, and keep their appearances in public to an absolute minimum.

"Promise you won't embarrass me," Morgan pleaded, and I did try. I wore my cool black clothes, and didn't lose anybody, and did not belt out "Tie a Yellow Ribbon 'Round the Old Oak Tree" in the middle of Stonestown mall. Morgan will tell you I asked the kids to hold hands going from the streetcar to the mall, but most of them knew it was a joke, I bet. Morgan's dad sneaked over for the singing, but he had his orders, and afterward he shook Morgan's hand very formally and said, "That was sort of OK."

Going to the Country
for a Christmas Tree

S o my new friend, Bill, had this idea to take the kids out to the country to chop down a Christmas tree. He saw the four of us getting a nice early start, then riding through the crisp countryside, exclaiming over the brilliantly colored leaves, singing Christmas songs, enjoying a day in the outdoors.

If I had any doubts, based on experience, about the bucolic perfection of a day in the car with the kids, or for that matter of the successful carrying out of any plan involving my kids, I kept them to myself.

Some things people should find out for themselves.

Sunday dawned. Morgan announced that she was totally up for going, as long as she could bring her friend Rachel, and we stopped at this pottery sale first. By 1 p.m. we were humming north on Highway 101, with Morgan's rap tape throbbing from the speakers. I couldn't tell if "Rigor Mortis" by Heavy D and the Boyz was helping to make this day everything Bill had dreamed it would be, or if he always gripped the wheel that way. "You will tell me if the music starts to get to you, won't you?" I said, and he nodded, and drove.

There was a tiny delay in Petaluma, no more than an hour, to pick up Patrick, who had stayed overnight with his friend Dusty O'Brien, so it was nearly 3 by the time we got on the road again, now with four kids squashed in the back seat, because Dusty wanted to come along, too.

"This is one of the prettiest drives I know of," Bill remarked when we turned onto Highway 12 heading east through the

Sonoma hills. The sun was by now slanting low across the landscape as we slid though a magical countryside, the silence broken only by the heavy beat of "Mo' Jerk Out" and by Morgan and Patrick's bitter dispute about who slugged whom in the back seat, and by my hissing at them to knock it off or else, and Morgan saying sweetly to Dusty, "If you loved me, you wouldn't wear those pants," and my attempt to distract them by opening Juice Squeezes and handing them back without realizing you had to shake them up first.

By the time we finished the mopping up, we were there.

Christmas trees marched up a slope, lit by the setting sun.

"I thought we were going to a real forest," Patrick said, with the resigned air of a boy who had been tricked again, and he and Dusty stalked off to find their own tree.

Despite the failing light, we found a bushy six-foot fir tree we liked, and, using my leather jacket as a ground cloth, the kids sawed it down. It fell on Patrick, answering the old question, if a tree falls on a boy in the forest and he laughs, did it really happen?

Bill cut down his own fir in one or two strokes. As we were dragging both trees to the car, I caught Patrick and Dusty just as they were about to saw down a 10-incher with Dusty's Swiss knife (all the trees were $30, regardless of size). While the sun slid behind the hill and the kids played in a nearby rusty junkyard, Bill figured out how to tie two large trees to the top of a Dodge Colt.

In no time we were on our way home through the now sleeping countryside, with the girls making up new words to Christmas songs, "In the evenings we'll perspire, as we steam by the fire." Patrick still wanted to know why we had to drive all the way out here to get a tree when they're for sale at Safeway, and Bill slapped his forehead and said, "They sell trees in the city? God, I am so dumb."

31

▼ ▼ ▼

Sound of Silence:
Must Be a First Date

I drove Patrick, 10, to the movies on his first date the other day. I know it's early for dating, but he's liked Nicole, also 10, for two years. When she finally agreed to go steady with him, he threw himself into my arms and said, "You can't imagine how happy I am, Mom."

Caught up in the moment, I said, "I'll drive the two of you to the movies."

I find my kids heartbreakingly vulnerable on these fledgling dates, having the choice of walking to the movies or going through these rituals right in front of their parents. I always lunge at the chance to do the driving, because if anybody's going to tease my kids it should be the one who loves them best.

I didn't mean that. Of course I don't tease them. It's true that when I was driving Morgan and a "total babe" she'd met at summer camp to a matinee, both of them stiff as dolls in the rearview mirror, I started singing along to "Tie a Yellow Ribbon" on the radio, but I stopped as soon as Morgan offered me 10 bucks. I probably could have gotten 20, but I'm not one to take advantage of helpless children.

I wasn't about to sing on Patrick's date, though. We were both too nervous. As we drove over to pick Nicole up, he grumbled, "Why is your car such a mess?" and tried to stack up the tapes at his feet, conscious of disorder for the first time since he was a baby who wouldn't eat a cookie with a bite taken out of it.

Nicole must have been feeling nervous, too, because she came out wearing a Sony Walkman over her ears. Her only other jewelry

was a mother wound around her little finger. "Do you mind?" the mother asked. "I couldn't persuade her not to bring the radio."

Mind? Heck, she could bring a television if it'd make her feel better. First dates are a nerve-wracking business.

I just hoped it didn't mean she wouldn't talk to Patrick. As I turned toward the theater, my turn signal sounded like gunshot in the tomblike silence of the car. "What did you do this summer, Nicole?" I called pleasantly over my shoulder.

"Uhhmmph."

I was fighting a fantasy of reaching back and performing an emergency radioectomy.

It wouldn't be the first time I've interfered. When Patrick was tiny, I'd go up to a strange kid at the playground and say, "What's your name? Are you 3? What are your views on sand-throwing and slide-hogging?" If the kid met minimal standards, I'd drag him over.

Remembering my promise to stay out of sight, I made Patrick and Nicole go in alone when we reached the movie theater. Patrick shot me a grateful look, taking the $10 I slid into his palm, but Nicole looked panicked.

When I met them in the lobby afterward, Nicole silently trailing Patrick by several yards, I again had to fight down an urge to interfere. Would it kill her to walk at his side?

We drove Nicole home in the same deep silence as before. After we watched her bolt for her door, I took a breath and said, "So how was the date?"

"Dumb," Patrick said cheerfully. She hadn't said a word to him the whole time, except to turn down his offer of refreshments, but he didn't seem to care. He turned on the radio, chalking the evening up to experience, and I drove home.

I was remembering that I hadn't actually dragged that many kids over for him to play with anyway. He'd found them by himself, just by plonking down in the sand and starting to dig. He'd be fine, if he could just get his mother off his back.

Family Stays, TV Goes

I announced to the kids at dinner that the TV would not be following us to the new house.

They were outraged.

"What are we going to do at night? It'll be so *boring* here," said Patrick. He had been about to give me the crust of his pizza, but now he was too mad.

"We'll play basketball, get a Ping-Pong table. We'll have hobbies. If we get totally desperate we can talk to one another," I said. "The fact that you think it'll be boring here without a TV is precisely why we're throwing it out."

Morgan saw where this was going. "I agree we don't *have* to have a TV," she said carefully. "There are lots of other things we could do. But there are lots of good things about TV."

"Name one," I said.

"We snuggle in front of it."

She had me there. I changed the subject.

"My dad always said the best thing he ever did for us kids was to keep TV out of the house when we were growing up," I said.

"We read books instead. Now I'm happy anywhere, as long as I have a book with me. People who grew up on television have to lug televisions around with them, which isn't nearly so handy."

But the kids were already heading for the living room. They learned a long time ago to take no notice of my feeble attempts at wit.

"We'll watch Bill's TV," Patrick said over his shoulder.

"It's not coming, either," I said firmly, following them.

▾ ▾ ▾

I was thinking about a juggler I saw down at Pier 39 not long ago. He stood on a swaying tightrope, juggling a hatchet and clubs and an apple, which he took bites of as it flew by.

The other shoppers and I stopped and watched, munching our hot dogs, or with our hands jammed in our pockets. No one thought to clap. At last, with the ax circling lazily inches from his naked throat, the performer called out, a little desperately, "This would be a good time to applaud."

Realizing all at once that we weren't at home in the Barcalounger watching "Star Search," we put down our Cokes and burst into wild clapping.

"I have an idea," Morgan said when the three of us reached the living room. "We'll tape a list of a hundred things to do right on the TV. Every time we want to watch TV, we'll look at the list first, and a lot of the time we'll decide to do one of those things instead."

I could just see her, deciding she'd much rather do some extra homework or throw a singles party for the unmatched socks than watch "Who's the Boss?"

Patrick had picked up the remote, but I shook my head.

"Then what are we going to *do?*" he said, throwing himself on the couch in disgust.

I sat on the couch with my book and waited.

After a minute Morgan got out all our games, but we couldn't agree which one to play. We had a spelling bee instead. Morgan started bleaching a pair of jeans, and Patrick found his book, *The Long Ago Lake,* and sat reading it. By 8 we were all in the kitchen again, trying to copy Morgan's moves as she danced to "Cherish" by Madonna.

Patrick's right. It's going to be really boring around here without the TV.

I can't wait.

Mothers and Sons
—and Homework

If you have ever dreamed of having a child, then you have dreamed of helping that child with his homework. The light of comprehension dawning on his little face, the child smiles up at you as you offer a lucid explanation of long division—yes, he *sees*. He excitedly scribbles the correct answer. "Gee thanks, Mom."

And this is exactly how it is, in real life, when you're helping one or the other of your children with his homework.

The only difference is that it's 9 p.m., and the two of you are staring at each other with loathing.

"Just start over, and show me the steps," you say, thinking with anticipation of the book waiting for you on your bed. "Pretend that I know nothing about long division."

But the child is not fooled. He's kicking his chair.

You'd like to kick his chair, too, but you're the mom. "Hmm," you say. "378 into 12,908. Shouldn't be too hard." Turning away slightly and coughing, you run the problem through the calculator hidden in your palm. "There's your answer," you say briskly, writing it down for him. "I'm supposed to show my work," the child grumbles. "How did you get that remainder?"

What on earth was a remainder? You knew that once, back in the Eisenhower administration. It's unfair to have to be doing subtraction now that you are all grown up and driving a car.

The child now remembers that he has to get a book on sea turtles for his report, assigned six weeks ago and due tomorrow. This is the first you've heard of it, you say, but the child is sure he told you

all about it. Also, somebody stole the sheet of paper with the social studies questions on it out of his locker at the rec center. If he goes to school without it the teacher won't let him go on the fifth-grade camping trip.

"The library is closed," you point out.

The child buries his head in his arms. He hates you. You should have sensed his need to go to the library tonight, and helped him remember his report earlier. You should never have made him go to that stupid school.

Now that the child thinks of it, you never take him and his sister out of state on vacation, and you don't do the wash often enough. He grabs the arithmetic paper.

"Thanks anyway, Mom, I'll do it myself," he growls.

You return happily to your book. Minutes later, just as you are getting to the exciting part, a drawn-out scream suggests that the child has changed his mind about wanting help.

When you huff downstairs, all warm and hopeful again at the idea that you are needed, he says, bitterly, "I'm supposed to figure out the distance between Yosemite and Yellowstone parks."

"Great," you say, relieved it's not long division again. He shoots you a doubtful look but tries to explain how to use the graph to calculate the distance. "Oh, I see," you say. But then there's a silence, and after a minute it's clear to him that you don't see anything. He's at a loss to understand how you keep your job.

You squint at his paper again, muttering to yourself about the base ingratitude of children and wondering who would want to go straight to another park anyway. The child sighs, clearly resigned to flunking out of the fifth grade.

If someone were to come into the room, he would see a touching sight: a mother standing over a child who is sitting, their faces alight in the circle of lamplight, bending together over a sheet of paper.

THE MODERN
WOMAN AFIELD

▼ ▼ ▼

"If God had
wanted us to be nice to one another
in cars, he wouldn't have invented
traffic."

▼ ▼ ▼

We're All Driving
One Another Crazy

N eil and I were driving on the Bay Bridge in heavy traffic when
he suddenly stopped the car. "What's the matter?" I asked.

"I'm being Politeness Man," he said, genially waving on a line of
cars waiting in a feeder lane from Treasure Island. One after another,
the drivers looked over in surprise, glared at Neil, and reluctantly
accelerated.

Neil didn't notice the glares. "See how easy it is?" he said in a
voice that reminded me of a teacher cutting up a frog in seventh
grade. "Now those cars will go out and be nice, too."

It is disquieting to find yourself cruising across the bridge with
a kind of freeway-going Mother Teresa at the wheel. Neil said he had
pulled this Politeness Man stuff on his ex-girlfriend, too, and she had
rolled her eyes and said, "I miss A—hole Man."

I know what she meant. It doesn't ring true, this idea of
encouraging other drivers to be nice. If God had wanted us to be nice
to one another in cars, he wouldn't have invented traffic.

Another time, Politeness Man himself confessed to me that he
was gleefully experimenting with not giving other cars the right of
way, just because he was driving a rental. And I notice he's the one
who goes nuts in traffic when a lane opens up and he's not driving.
"Come on, now, *turn*," he yells at me, in agony because other cars are
beating us to the intersection.

It's not just Neil. Everybody I know grows claws and fur behind
the wheel. My old boyfriend, Nick, used to barrel down Sansome
Street honking his horn at *parked* cars, lest they decide to start up and

turn into his lane. Kate, an easygoing acting teacher, snarls, "Get your finger out of your nose and drive, Harvard!" when the little Volkswagen in front hesitates more than a split second after the light turns green.

Even my friend Craig, as sweet a guy as you'll find, once whizzed blithely up the dirt shoulder to jump to the head of a line of cars waiting to park: "I'm assuming my natural position as leader," he grinned.

Away from the road, it's a different story. You don't snap, "We don't have all day, buddy," to someone stumbling onto the Fremont train ahead of you, or elbow your way in to assume your natural position as head of the popcorn line at the movies.

Of course you don't. Somebody might see you. Somebody you know.

Ah, but in your *car.* That's different. They can't see you in there, can they? Not behind the one-way glass of your windshield. In your car you're anonymous, omnipotent. Every vehicle on the road is an enemy, a rival for your lane, your parking spot, your place in the sun. It's every car for itself out there.

If someone *were* to see you in your car, if you were to glance over in horror and see that the Honda you squeezed onto the median contains your girlfriend, or the desperately signaling sedan you imperiously refused to make way for is being driven by the guy who just interviewed you for a job, then—and only then—you might realize that you are not yourself on the road, that something savage and elemental has you in its grip.

But with 2 million cars in the Bay Area, what are the chances you'll see somebody you know? You're home free.

Politeness? On our streets and highways? Not in our lifetime. It would mean giving up too much.

After all, it is only here, in your very own castle of rubber and steel, that you can for a short but blissful time throw off the cloak of civilization and be the raging Hun you always wanted to be.

▼ ▼ ▼

Taking Back a Scarf

This year a generous acquaintance gave me an Hermes (air-mess) scarf, green with a hunting motif, and as I don't wear scarves I thought I would exchange it for something else, maybe some nice warm socks.

So I tripped on down to the store at the posh and perfumed corner of Stockton and Geary. A doorman ushered me out of the biting wind and into a small space that ascended in a series of levels, like an unfolding scarf.

A clerk in a blue blazer approached, and I gave him my most patrician gaze. I was wearing jeans and worn Reeboks and fully expected to be taken for one of the eccentric rich. He whisked my orange box away and returned a moment or two later with a store credit slip for $209.

Two hundred dollars for a scarf? With horses on it?

This was *great*. I could pick up some things for the kids, maybe a winter coat for myself, a nice saddle . . .

As I looked around, I wondered where all the famous Kelly handbags were. I didn't just fall off the turnip truck. I know stores like this keep a lot of stuff in drawers, where the riffraff can't paw it with their eyes.

Later I heard they didn't even have any: As soon as one of these coveted purses comes in, it goes to one of the desperate women on the waiting list, all of whom are carrying their stuff around in paper bags in the meantime.

▼ ▼ ▼

I already have a purse, so I asked to see the leather jacket hanging above my head. Four thousand dollars?

Well, OK, maybe a belt. Belts were $250 and up. I spotted a nice sweat shirt, perfect for watching the game, for $1,000, and some understated wallets, good for keeping old money in, starting around $500.

It took considerable patience on my part to extract this price information. The clerks seemed embarrassed to have to mention money at all.

One clerk wore a red tie with gold horse bits on it that I supposed I could get for the main squeeze. How much was that?

Alas, they didn't have anymore, he said. Those ties sold out the day they arrived. I was getting the picture: Hermes customers, tieless and purseless, all crowd onto the pier the day the ship arrives from France. Whatever actually reaches the store is the sort of thing they leave around for off-the-sidewalk types like me.

Wait, the clerk could not stand seeing me upset, and he remembered he might have one more. Yes, here it was in the drawer. It was only $125, and he was sure my companion would like it – he had seen him in here often. (He hadn't, but Bill is the sort of person you're sure you've spotted in the Hermes store, whereas I'm the one you're convinced made off with your pitcher of suds at the beanfest.)

I had $75 left. Trying to convey my chagrin at even having to mention such a paltry sum, I wondered whether I should just take it in change. All of a sudden the ridiculously overpriced $70 Guess? overalls that Patrick is pining for were looking like the most amazing bargain.

No, the clerk shook his head regretfully. Store policy, alas. How about this nice vest-pocket scarf? It would go with many ties, not just this one, and it was exactly $75.

I had the tie and handkerchief put in separate orange boxes, the ones famous for opening with a single tug on the ribbon. (Two tugs are so exhausting.) If the squeeze decides he doesn't like them he can swap them for that nice beach towel they had upstairs, only $200.

Debbie and Tina
Want to Have a Baby

I was just biting into my sandwich when Tina said, "Debbie and I want to have a baby. You have kids. What do you think? Is it fair to the baby for it to have a lesbian couple for parents?"

I was thrilled to hear she was contemplating parenthood. Tina, a part-time design consultant in Petaluma, is one of my oldest friends, and not just because she understands the importance of gossip and dissipation in the workplace. She's smart and amazingly kind, listening sympathetically to tales of romantic misadventure from me that would have Mother Teresa on the floor. If she has a baby, I want to have lunch with it.

Will her baby suffer from having two women for parents? Well, I think so. Kids suffer from having off-white shoelaces if everybody else has white ones.

And there might be other problems. I saw that *New York Times* story about the legal and emotional horrors awaiting gay couples who separate and battle over the children. Imagine the pain of being told by a court, as one woman was (she was listed as the father on the birth certificate) that the child you have matched your breathing to since its birth is not "the legal or biological anything" to you.

I know this is a hard issue for some, but surely we'll find ways to give gay couples the same rights to their children the rest of us have—starting with the right to have their parents be married to each other. (Everyone should enjoy the full disadvantages of this institution.)

On the other hand, I have a feeling Tina and Debbie will let that baby know they think it's the greatest thing since air. They'll

buy it the $70 Guess overalls it demands and go to pieces every time it coughs. They'll laugh at its jokes, teach it to step into its swing and tell it why the sky is blue.

This baby will wish it had a dad, but not if it means swapping parents with anybody else on earth.

By the time the waiter brought our coffee, Tina and I had, at least in my mind, dispensed with any silliness about whether she'd be a good parent. We were now discussing whether the moment ever arrives in anybody's life, gay or straight, when you can say, this is it, I'm ready to be this terrific parent. It's simply too conceited and scary a thing to decide.

What really happens—what almost has to happen—is that while you continue to feel sorry for any kid who gets stuck with you for a parent, one night your mate's T-shirt comes untucked on one side, impairing your judgment. Perhaps there has been a particularly wonderful wine, or you can't agree on whose turn it is to trudge to the bathroom for the birth control stuff. One of you whispers, "What the hell, I love you, let's make a baby."

I recommended this course to Tina, but she couldn't quite picture schlepping a bottle of champagne and two glasses over to the romantic, candlelit artificial insemination clinic.

She and Debbie are stuck with doing the mature thing, talking to each other about what it would be like to be parents, worrying about its welfare before it's even conceived.

Why is it always people like her who ask themselves these searching questions—never the ones who shouldn't have unsupervised custody of a footstool?

All this, of course, is very good for this baby with whom I have a tentative lunch date—and for all the babies adopted by gay couples after long soul-searching.

And it's good for the rest of us, who get to welcome all these loving new parents to the fold.

45

▼ ▼ ▼

Who Taught Me to Drive, Anyway?

We were halfway up a steep street when I stopped the car. A mechanic named Jody sat beside me, watching to see how I operated the clutch on a hill.

I pulled on the emergency brake, put the car in first gear, eased out—and that horrible smell filled the air.

That smell has haunted me since I bought the car. It's the smell of failure, of incompetence, of money burning. It makes me want to take a blowtorch to the black sports car I paid $17,000 for.

That smell means I am on my way to serving up my second cooked clutch in less than a year.

My boyfriend, Neil, who is as sympathetic as a man can be about my plight, which is to say, not all that sympathetic, wants to know why I cook only clutches, why it's never, say, a pork roast. But Neil finally admitted he had scorched my clutch himself.

"There's something the matter with this car," he said with a conviction lacking in our earlier conversations, when it was only me burning the clutch.

So I brought the car back again. This time Jody didn't ask me if I had ever driven a stick shift before, which is the standard question if you took girls' gym, carry a purse and have fried your clutch a sickly yellow-green.

When the first one went out, we had established at wearying length that I had been driving stick shifts in San Francisco for 20 years.

"But are you used to front-wheel drive?" Jody was asking now.

Luckily, I said no. If I had said yes, he might have said, "But you have no actual *race-car* experience, have you?"

I pulled around the corner, switched off the engine and was staring out the window, enraged at the car, at myself and at the mechanic sitting patiently beside me. He was probably thinking exactly what I was—that there's more to owning a sports car than writing out a check.

When we changed places, Jody smoothly eased the car uphill from a dead stop. No smell. He handled the car with the skill of a race-car driver, which it turns out is what he is on the weekends. He said he'd like to drive a souped-up version of my car in a rally. "This is a hot little car you have here," he said, admiringly. You goofy woman driver, he did not add.

Jody was sufficiently discomfited either by the way the car was behaving or by the way I was to turn me over to a manager, Mike. Mike was wearing a tie instead of a white coat, so I knew I was moving up in the organization.

Mike was very nice. "Have you driven front-wheel drive before?" he asked, gently. By way of answer, I jammed on the gas and swerved into the intersection so sharply that he fell out the passenger door. As I roared off I looked back in the mirror to see him sprawled, blinking in surprise, in the middle of the road.

That's what flashed through my mind, anyway, when he asked me that. No one held up his hand to refuse my proffered check when I was buying the car, saying, "You *are* used to front-wheel drive, aren't you?"

Mike eased the clutch out as smoothly as Jody had. I got their point. It is possible for some people to drive this car without smoking the clutch. Car dealers, race-car drivers.

I let Mike show me how to give it less gas, keep the RPMs down and get my foot off the clutch fast. During this lesson, which must have looked odd, a black sports car lurching by inches up Potrero Hill, he forgot himself for a moment, and I heard him mutter the word "tricky," meaning my clutch.

I'm pretty sure he said that.

What Price Price Club?

M y friend Marjanne mentioned that she was going to the Price Club and was willing to take me.

"I have much too much work to do," I told her. "I can't go out shopping, just like that."

"I do, too," she said. "I'm way behind on my November invoices. Should we take my car? It holds more."

I had begun to have a disturbing feeling that everybody in the Bay Area belonged to the Price Club but me. While I am out at the No-Price-2-Hi store, paying full retail, they're out there in their minivans, loading up on cassette tapes and frozen asparagus.

I had the further unhappy feeling that at least one person has to pay full price so others can skip merrily home with discounts, and I feared that person was me.

Today, however, that was going to change.

When we arrived at the huge windowless warehouse, I looked around, riveted, at the stereos, cookware, film, watches, jewelry, liquor gift sets, razor blades, tires, socks, sheets, stationery.

Hardly noticing when Marjanne disappeared, I grabbed an oversized orange cart and headed into the crowd. Some people were pushing industrial pallets, piling toilet paper and pancake mix and cases of Kahlua on them as if it had been announced that all buying everywhere in the world would cease in 15 minutes.

I began to throw things into my cart, at first slowly, then faster and faster. My list forgotten, I lobbed in everything I saw that I have ever used: a 24-pack of film, a lifetime supply of tampons, 100 plastic

tumblers, champagne, couch throws, Christmas wrap, Reeboks I didn't even try on.

Everybody I saw was doing the same thing. It was as if we were all Scarlett O'Hara in *Gone With the Wind,* whispering, "As God is my witness, I'll never pay retail for toilet paper again."

Veterans say it's dangerous to let people go to the Price Club alone the first time out.

"A gallon jug of maple syrup," the novices think. "What a good idea. A *case* of gallon jugs of maple syrup—what an even better idea."

For everything I grabbed, I had to leave scores of other things behind, including a huge box of the Eggo frozen waffles the kids like. If I cleared everything else out of my fridge, including the ice trays, I could fit the waffles in. If I moved the kids out of their rooms, I could take advantage of these terrific bargains in paper towels. If I moved out myself . . .

I calmed down, but not before I bought about 30,000 granola bars. The kids will polish them off by the time they start college, I figure, and can start on the frozen pepperoni pizzas.

I handed over $337 to the cashier my first time out, which is about the average for a first-timer, they say. The Price Club is so cheap that you end up spending a fortune.

But I suppose I saved money in the long run, and I suppose I'll go back—I'd be a sucker to pass up these bargains, wouldn't I?

Wouldn't I?

In truth, the place gave me the creeps. So much consuming, at such dreadful speed, and in such dreadful quantities. They even have food stalls with samples at the ends of aisles, so you can get started on your consuming right away.

It reminds me of the time when I was about 4, and an enterprising neighbor girl decided, while her parents were out, to sell everything in their house for 1 or 2 cents apiece. I got some good deals that day too, but as I was lugging it all home in my wagon, I felt something was wrong. At 4 I couldn't put my finger on it.

At 37, I still can't.

What City Folks
Don't Expect to Run Into

A few days ago, as I was double-parked on Market Street, a kid in a battered blue Falcon drew up beside me and yelled, "Want to get that dent fixed?"

I looked at his car. It was as if Cyndi Lauper said, "Want to get that hair fixed? Real cheap."

Still, I'd had the dent for months. Some lowlife plowed into my door one night and then ran off. "Mom!" Morgan shouted. "There's a really huge dent in your car!"

I decided not to think about it. I have collision insurance, but there's a wicked $1,000 deductible.

I thought my problem was solved when, about a week after the hit-and-run, I found a little yellow Post-it note on my windshield. It said, "Hi, I dented your car. Very sorry. Please call me. Cindy."

I called. Cindy had no insurance and no money, but promised to find a way to pay me if I would get an estimate. I did, but my initial elation died down when, in thinking about it, I realized that Cindy's note didn't say, "Hi, I dented your car a week ago, and my conscience has been bothering me."

I called back. "The bad news is that the body shop says $900. The good news is that I don't think you dented my car, even if you did roll into it."

Eventually the dent started rusting. I bought some primer. I didn't put it on, but kept it in a bag in my bedroom, as a warning to the rust not to spread or else.

So here was this kid. "My name is Tom. I'll fix that for $110," he

was saying. "I have my tools with me. If you don't like my work, you don't have to pay me."

I got him down to $40, then pondered. I knew I wasn't supposed to let some guy start pounding on my car. But the car was already dented. As far as I could see, the worst that could happen was I would be out 40 bucks.

Besides, there was something disarming about this kid, something about his open expression and the way he had said, "my work," as if it meant a lot to him.

Tom met me at my house, and, refusing the beer I offered him ("I don't drink"), went straight to work, banging on my car with a flat-head hammer, then punching holes in it. As I nervously watched him insert another instrument to pull out the dent, he told me he grew up in San Francisco and left school in the fourth grade. He's 19, has a wife and a baby and is saving to buy a partnership in a body shop. "I've been doing this since I was 7," he said. "My dad taught me how."

Two hours went by. Using his car lights to see by, Tom plugged the holes and smoothed the area where the dent had been with bondo plastic, then painted it with black primer. He was working so hard that his breath came in pants.

Then he was done. "What do you think?" he said, proudly running his hand over the surface of the car. The dent was gone as if it had never been. I handed him $50. "You do terrific work," I said, and he beamed. We shook hands, and he gathered up his tools and went home.

On the one hand, you have city-fearfulness—a stranger in an anonymous car, nothing in writing, no guarantee the job will be done right. He was not accountable—and in this society we like people to be accountable. How do I know you'll do what you say you'll do? I'd like that in writing, please.

On the other, you have a man, his tools and his obvious pride in his own skill. If for every hit-and-run driver there's a Cindy, who left a note though she had no money, then surely for every guy out to take advantage of you, there's a kid like Tom, whom you don't have to pay if you don't like his work.

Cautionary Epilogue
for Inspirational Tale

A couple of weeks ago I told a story about a kid who stopped me on the street and fixed a dent in my car door for $50. "If you don't like my work, don't pay me," he said. It was a simple tale, and it even had a moral – that it's still possible to make a deal with a handshake, relying on a man's pride in his own skill.

The rest of the story isn't nearly as simple. It's so full of unresolved questions, mistakes and moral ambiguity that it begins to look like, well, real life.

A lot of you responded to the original tale. I have a pile of letters scolding me for paying Tom, who is supporting a wife and baby, a measly $50 when a body shop estimated the damage at more than $900.

I have a list of people who want to give Tom more work, so he can get that body shop of his own, but he left neither a last name nor a phone number. He promised to come back and paint the car but didn't.

And I have a sizable stack of letters from irate customers begging me to warn people that, as one reader said, "For every honest Tom, there are 10 young gypsies working around malls or supermarkets who bang the fenders a bit and cover it with interior spackle that falls off as soon as it rains."

So I am warning you.

First, though, as for my under-paying this Dickensian Tom, come on, now. Tom's "I'll do that for $110" signaled the opening of negotiations, not what he expected to settle for. And, as it turned out, $50 was about right for what I got.

▼ ▼ ▼

When I gave up waiting for Tom to call and went to see about getting the car painted, the guy at the first auto body shop said, "I can do it for $200. Course, that bodywork will have to be done over."

"I can paint over that job, but it won't look right," said the man at the second shop. He got out a ruler to show me what my own eye had missed—a dip in the surface.

"Is it ever a good idea to use these guys who stop you on the street?" I asked the third guy as he ran a disapproving hand over my door.

"Sure," he grunted, using the top of my car to scrawl an estimate.

"When?"

"When they're good."

Tom was good, but he wasn't great. He left a depression or two in the panel behind the door, though it still wasn't bad for a guy working on the street in the glare of headlights.

And it could have been a lot worse. A reader says, "I was stopped on Market Street by a group of young men—for $100, they would fix the dents. They went to work on it in my carport, punching the holes, then mending them very cursorily. The job would be completed the next day when I came to their address on Pine Street. And I went along with it, giving them $100. The next day, of course—a bogus address on Pine Street. The body shop man told me it was one of the most common scams."

Tom was not running a scam. He had seemed to promise more than he delivered, true, but I had been prepared to pay less than the job was worth. It was a fair deal, although it was also probably stupid, given what a poor repair job subtracts from the resale value of a 1989 Toyota. Maybe the truth is there are no simple stories left. Maybe relying on a man's word and the work of his two hands made sense when it was a wagon wheel you needed fixed, not a ton of furious metal.

Or, maybe the answer really is simple: As they used to say on "Hill Street Blues," be careful out there. Or at least be careful what you pay for, lest you get it.

THE MODERN
WOMAN AT HOME

▾ ▾ ▾

"Stack up all the
books you've been meaning to read
so they form a nice little drink stand."

▼ ▼ ▼

I'll Get Older
But I Won't Grow Up

People in stores call me ma'am. No one scolds me if I weasel out of my appointment with the dental hygienist with a tissue-thin excuse or wear flip-flops to work. I'm 36 now—halfway through my allotted tenancy in this particular carcass. It's beginning to dawn on me that this is it—adulthood.

What became of that magical moment when I would stop feeling like a kid and start feeling like a grownup? I thought it would have happened by now.

I still feel exactly like me. I look down at my feet, and they're the same two ungainly appendages that I stuffed into $3 supermarket tennies when I was 12.

If my mother walked into this room and said, "Quit fooling around and clean up your room," I'd be halfway down the hall to the washing machine with a pile of dirty laundry before I remembered that I'm a grownup now and can hang the laundry from the damn lamp posts if I feel like it.

When I was little, I could tell the difference between kids and adults. Adults blocked the sun in doorways, drank bitter liquids, drove cars and led a secret, steamy life behind closed bedroom doors. I assumed I would become an adult when I turned 21, or when I got a job, or when I started to eat my mashed potatoes without first hollowing out a peripheral canal to send the gravy down to the pea forest.

I was consciously coasting. I thought I would probably be famous, but I didn't see what I could do to bring this about when I was just a little kid, so I relaxed and did not even decide on a line

of work, waiting for the day when I would wake up and find myself a grownup.

Maybe I'm an adult because my friends are. Could that be the way you tell? My friends are tall and drink coffee and have sex. They also eat strawberry ice cream straight from the box and hide notes from their dentists and push their swiss chard off into the Siberian side of the plate. They buy themselves high-rez toys and play card games and sulk when their names are left off memos.

Maybe no one actually turns into an adult. Maybe you just get to be an older and older kid. Maybe the whole world is being run by old kids.

I'll bet the really old kids—those collecting social security—feel this way. That guy staring out the window at the retirement home is still wondering when you stop feeling like a kid. He's still in the tree house, refusing to come down because there's liver for dinner again.

Haircuts Come Back
to Mom's Scissors

M y first experience with hairdressers was not a happy one. I was sitting out in the yard on a kitchen chair with my eyes squeezed shut, breathing in hair, while my mother said, "This isn't going to turn out if you don't hold still."

It wasn't going to turn out no matter what I did.

She would begin with the bangs, which she was determined to get perfectly straight. Ignoring the ringing phone and the occasional pot boiling over in the kitchen, she would snip across my temple, then draw back to judge the result. She would purse her lips, snip some more, then call somebody else over to look.

"Take a little more off the left," my 6-year-old brother, Shannon, would say, and Mother would say, "Oh, I think you're right," and snip again. This would be repeated four or five times, until she had to quit because she had arrived at my hairline.

At first I was convinced I was just going to look stupid all my life. My teens and 20s were a festival of shags, Sassoons and a permanent that made me less like an unmade bed, which is what I secretly wanted to look like, than like a mattress bursting with springs.

But I kept looking. I believed that hairstylists' years of training had honed their instincts for knowing exactly which hairstyle went with each face, just as I believed that after combing one's hair every single day for 30 years one would eventually get the hang of it.

Far from presuming to tell these experts what I wanted, I gave them very little direction, in order not to interfere with their genius. And they asked for very little, for the same reason.

I went to Mr. Robert, Mr. Patrick, Mr. James. Mr. James gave me a glass of chilled chablis and a gown to protect my clothes—or maybe to protect himself from the sight of them—and lifted my hair with both hands, obviously struggling with his feelings.

"I think perhaps it is not too late," he said. Four hours later, he had some money I had been planning to use for rent and I had a stunning haircut that I immediately wrecked by stepping out into the breeze. It would have been fine for someone who was going to be living in the salon.

Desperate, I decided to try one of those fast-hair places. Great Cuts, Short Cuts, whatever they're called. Nothing about these places is reassuring—not the locations far from the center of town, not the orange and brown balloons, not the little kids waiting their turn. Even the prices are scary. They're so low—less than 10 bucks— that they remind me of Mother saying, "No use paying good money for a haircut."

Least reassuring of all are the operators, young women who chew gum and break off to take calls from their boyfriends in which they discuss how many cases of beer they will need for Lake Berryessa. Their own hair looks as if hair's the last thing on their minds.

When my turn came, one called Linda, her own hair a startling red, sat me down and said, "What did you have in mind?"
"What?"
"How do you want me to cut your hair?"
She was evidently determined not to proceed without instructions, so I told her what I wanted—bangs swooping low to hide a forehead I've always loathed, hair trimmed at the sides, whatever she liked at the back because I can't see it. Half an hour later, that's exactly what I had.

Even my mother liked it when I drove over to show her. "It's wonderful," she said. "Just perfect, except that your bangs are in your eyes. Why don't you run and get my scissors from the drawer, and I'll just touch those up for you."

▼ ▼ ▼

The Difficulties
of Getting Dressed

S omething about the way Bill was looking at the invitation – just the way his fingertips ruffled the edge of the card – told me there was a dress involved.

I sighed inwardly, thinking of my frocks, rammed to the back of the closet. None of them is right, not for this event, though each represents time stolen from work, money, embarrassment, uncertainty, angst, regret.

Even the kids were tired enough of my old black skirt and jacket this year to rearrange their own schedules one Tuesday evening to drag me to Macy's Social Dresses (where not so much as one dress said hello).

My team went through the racks like a police sweep. I would hold up each crinkly, overwrought dress, and Patrick would shake his head. "Nope, that's see-through." "Too many flowers." "That's for a fat lady." "Not formal enough."

After a while, I just waited in the cruelly lighted cubicle, putting on whatever came over the door. "Try this, Mom."

Patrick held out for a shimmery silk, and Morgan came up dragging a wildly beaded black and white cocktail number she thought the two of us could share, and I stumbled across a velvety frock with a little jacket to cover my winter-white arms.

I resolved it by buying all three, intending to take two back when everybody had calmed down, but I intended all along to keep the velvety number because I had an idea Bill would like it.

▼ ▼ ▼

I don't buy dresses to please the kids, and I don't buy them to please myself. I buy them to please the man I'm with.

I realize I'm going to be drummed out of the sisterhood for saying I do anything to please a man, but it's the truth. If it were strictly up to me, I wouldn't get within a mile of a dress. My twin's the same way: Her husband had to *marry* her to get her to put on a dress, and it lasted 40 minutes—she brought jeans rolled up in her purse to the chapel.

Dresses are hard. You have to find one that works out and eats right and stands up straight and somehow says the fact that you're running the corporation doesn't mean that a tryst in the broom closet is out of the question.

When you do find just the right rag, you give up lunches to pay for it and to fit into it, and look all over the place for stupid heels to match it, and you put it all on and he has exactly nine seconds to tell you how wonderful you look.

In my ideal universe, you either don't have to wear a dress at all, or, if you do, you get to wear the same LBD (little black dress) over and over, like a favorite old bathrobe, until it falls apart.

Men wear their LBSs—little black suits—until they shine with age. At the opera the men look, the hundreds of them, as if they all called each other up and said, "What're you wearing? The tux? Great, OK, I'll wear mine, too."

I shook off my LBM (little black mood) and was going to wear that velvety number to the company party this year, but a notice in the office said, "Dress casual, dress warm" (it was at the Maritime Museum). So I wore a gray jumpsuit, and several people, all of them women, said it was spiffy, but it kept reminding one guest of his boyhood in Illinois, when everybody wore long union underwear.

The other women traitorously wore dresses. One wore an off-the-shoulder green taffeta that was neither casual nor warm, but simply annoying. I caught Bill glancing at a photographer in a short red dress with a green jacket, all covered with sequins, with such wistfulness that he nearly impaled himself on a spar, which would have been too bad.

▼ ▼ ▼

The Fault Lies Not in the Stars

O ne of the things I like least about myself is my unholy skepti-
cism. When other people speak to me about est, organized
religion or channeling without benefit of Viacom, I have the choice
of either, as Mark Twain said, believing what I know ain't so, or
searching for a truth that even a skeptic can believe.

I have tried, naturally, to suspend my pesky disbelief, especially
when it comes to reading my horoscope in the paper. It's the only
place in the paper that takes any interest in what kind of day I per-
sonally am going to have, so I read it religiously.

I did have one period when I realized it would be easier to enjoy
reading my horoscope if I weren't a Capricorn, which is a dour,
doubting sign. I would feel far more comfortable if I were another
sign—a Leo, say. Leos have more fun, and, more important, Leos
believe in astrology.

So I became a Leo, indistinguishable from other Leos except for
having a birthday in January. I told everyone I was a Leo, and even
had a Leo key ring. I even began looking like a Leo.

But it didn't work. Too many people knew or guessed I was a
recovering Capricorn, and besides, I couldn't stop myself from peek-
ing at my old horoscope. On some level, I believed. Now it's all I
read again—or was until last week, when my personal news front
grew capricious.

On Tuesday of last week, my horoscope said, "Romance looks
great!"

This was terrific. As a Capricorn, I'm usually assured I'm about

62

to succeed in stomping all over everybody else at the office. I hummed to myself all day, dressed extra carefully. I invited a man to dinner.

Wednesday's horoscope didn't mention romance – only something about maintaining an air of calm in my business dealings, which I don't have any of. But on Thursday when I opened the paper, it said, "Put romance on the back burner while you concentrate on your career."

I was surprised, but then Thursday was the day I announced I was going to write my book. Awe-struck by the perceptiveness of the stars, I canceled the dinner.

Next morning – Friday – I read the paper again. "Romance will take a turn for the better if you show more initiative."

What happened to the back burner? The stars were developing a very short attention span where I was concerned.

This forced me back to my original quest, which is where to find something even a skeptic can buy. I reread "What I believe," a 1939 essay by E. M. Forster, an English novelist who distrusted wholesale systems of belief so much that he came up with his own alternative: personal relationships.

"Here is something comparatively solid. . . . One must be fond of people and . . . trust them if one is not to make a mess of life," he wrote. Forster believed, with all his heart, in an aristocracy of the sensitive, the considerate and the plucky.

"They are sensitive for others as well as for themselves, their pluck is not swankiness but the power to endure, and they can take a joke. . . . With this sort of person knocking about, and constantly crossing one's path if one has eyes to see or hands to feel, the experiment of earthly life cannot be dismissed as a failure."

Maybe it's me, but it seems Forster's aristocracy has got it all over astrology and channeling, if one is searching for something to believe in. I'll never stop reading my horoscope, though – or at least not until I find out what sort of initiative I'm supposed to take in getting romance off the back burner.

▼ ▼ ▼

Blonde Dyes by Her Own Hand

I stopped darkening my hair this weekend. It was kind of sudden and not altogether successful.

OK, it was a disaster. All I had meant to do was frost my hair, which I've been doing since I was a kid. You buy a kit in the drugstore for 10 bucks and lighten selected strands. Salons will tell you home kits don't work, but they do.

Salons also require appointments, and the thing about frosting your hair is that when the impulse hits, you have to do it right that second. One minute I was peacefully reading a book, and the next I wouldn't be happy until I could pass as a stunt double for Marilyn Monroe.

I asked my neighbor Marjanne to help. She runs a leading executive-search company out of her living room, but was more than happy to abandon the phones and fax for a hair-frosting party. This is female bonding at its finest.

Marjanne came over, accepted a glass of my premium house red and recklessly pulled a thick strand of hair out of every hole in my frosting cap while I sat on the floor with my own glass. Then she remembered she had a turkey in the oven and went tripping home while I smeared on the hair goo and went back to my book.

Hours passed. By the time I recalled I had a corrosive solution on my hair and rushed to wash it off, it was too late. When I lowered the towel, there in the mirror was the new me—a daffodil wearing a shocked expression.

I didn't panic. It was possible, I told myself, that being alone was making me overreact. My hair might look just fine to other people.

Ten minutes later I met my 9-year-old son, Patrick, and his friend Edward in the hallway. "Mom?" said Patrick. "What did you do? Can you bleach it back?"

"It looks as if I could walk over and lift that off your head," remarked Edward.

When my ex-husband saw my new look, I saw a merry expression on his face I haven't seen there for years. "It isn't so bad," he grinned.

I was just glad I was able put that spot of joy into his day.

I went to bed wanting to kill whoever it was said blondes have more fun. The next morning I woke at 6 and realized that I could now do anything I liked to my hair because it couldn't possibly get worse. I drove to the 24-hour Safeway, grabbed a box of Medium Ash Blonde off the shelf, brought it home and sloshed it on.

Twenty-five minutes later I looked in my mirror and thought— hey, not bad. I was very, very blonde still, but this at least was a color occasionally found on human beings.

The reaction has been mixed. Patrick still wants it back the way it was. I don't blame him—Mom is supposed to go on looking like Mom. Other opinions I take with a grain of salt. My ex-husband, trying to talk me out of frosting my hair, used to rhapsodize about the terrific copper highlights I had when I stood under the light, and I would think, "Great, I'll just carry a lamp around with me."

The heck with the natural look. After all, you can't take credit for what you're born with, only for what you do yourself. Where would Marilyn Monroe be if she'd clung to the hair color God gave her? We'd have a movie called "Gentlemen Prefer Mousy Brown Hair."

My boyfriend said he liked my hair this way, which he'd better. As Shakespeare said, "Love is not love which alters when it alteration finds."

I know he was talking about hair color.

▾ ▾ ▾

Roots Two: the Sequel

From the number of people who have been making remarks about the color of my hair lately, you would think there's something different about it. "Isn't your hair, uh, lighter than the last time I saw you?" my friend Sinclair asks.

I don't know what they're talking about. Really, I don't. My hair has always been the same shade it is this week, a kind of strawberry blonde. Hasn't it?

I know it has, and Mickey Spillane knows it has. "Blondeness," he says, "is a state of mind. Blondes can twist men's heads right off their shoulders. . . . Somehow, every woman is a blonde; the way every man is a superhero."

I know what you're thinking. To twist men's heads off their shoulders, the insecure little thing has dyed her hair.

Nothing could be further from the truth. I don't dye it. Dyeing hair is a cheap, trampish thing that one does only to elude the law or drive up one's street price.

I simply take a few tiny steps to reveal to the world my essential blondeness.

These steps were not at first highly successful. Like a baby learning to walk, a woman coming into her blondeness for the first time will not do everything absolutely right the first time.

First, as some of you will remember, I wound up with hair so orange you could hail me and order me to take you to the airport. Then, to fix it, I dumped on a box of Clairol ash blonde.

Since that moment, I have found myself on an unfamiliar road.

I've been frosting my hair since high school, but I'd never had to deal with what happens when it all grows out at once.

The instructions on the Clairol box had anticipated this setback. "Three to four weeks after you've applied your haircolor, you'll want to touch up the new growth at your roots."

This is true. You will want to touch those up, and in a big hurry. Roots make it look as if you dye your hair.

The instructions continued: "It is not necessary to re-color the full head unless the color needs refreshing." This was exasperating. Did it mean I *could* recolor the full head if I wanted to? How was I supposed to get this smelly blue goo on only the bottoms of my hair?

When I complained about this to my friend Marjanne, she said to stop trying to do it myself and go to her salon, the House of Scary Hair.

There I asked the operator, who had locks the color of pooled blood, if she'd ever been blonde, and she said, "Yes, on one whole side." I explained carefully that I lived a quiet life and needed quiet hair. She nodded, then picked up a tiny wisp of my hair, studied it, wrapped it in tinfoil and picked up another. Time passed. Civilizations rose and fell, and when I was done I had new highlights so subtle that even I couldn't see them.

In despair, tired of the whole business, I was even thinking of letting my hair return to its natural lustrous sexy shade of mouse brown. But my sister Adrian said I couldn't. "After the age of 2," she reminded me, "dark hair ages you."

Like a Jedi knight, I must never turn to the Dark Side. Finally, I got mad enough at the problem to start throwing real money at it. I called Mister Lee's, where the opera crowd gets its hair colored, tinted and highlighted, but never dyed.

It's very restful here. Every five weeks or so I give them a couple of hours of my time, and they give me some magazines designed to lower my IQ while they go look up my formula. Sometimes we skip the formula, and I just go with the color the operator has.

Why, you ask, your lips pursed in disapproval, do I do all this? Because it's fun.

On a Heel and a Prayer

E very woman remembers when she got her first pair of high heels. There you were, 16, wobbling to and fro in your bedroom while your date for the prom was downstairs being grilled by your parents. You felt grown-up, sexy, a little dangerous. High heels are a rite of passage, like the first shave or learning which South of Market streets go through and which don't.

I can remember my own first pair of heels. It isn't exactly lost in the mists of time—it was last year, when I was 36. I was hoping to put it off forever, just slide through life in flat shoes. But I had this boyfriend, Nick, who put down his foot (comfortably encased in a black wingtip) and said it was mandatory. His company was giving a big do at the St. Francis, and I was his date, and I was to come in high heels, and behave myself for once, and not make impertinent remarks, or tell my favorite joke about the dyslexic priests, or drink too much, or take off my shoes. Above all, I was not to take off my shoes and throw them away, although this was unfair as I only did that once, and the shoes had it coming.

Still, I knew that there is a time to be born, and a time to die, and a time to wear high heels. Resolutely, I made my way out to Connie's Shoes in Serramonte and wedged my size 8 feet into a pair of pink shoes with half-inch heels. While the salesgirl acted as spotter, I stood up and found myself perched on a pair of very small, very sharp hills, with my toes pointing toward the abyss and the rest of my feet trying to follow. There were no ski poles.

The night of the party it was raining, naturally. Nick had gone

ahead to get things ready, so I took a cab. I wore my scuffed, comfy flats to the 10th floor of the hotel, and then hurriedly switched to the pink hills, stuffing the flats in my purse. By the time I was lurching with palsied stride down an endless carpet toward the room where the party was, I had lost all interest in Nick, in his entire sex, and in my own. I just wanted to make it to the party room without falling. It didn't help that an awful lot of people seemed to have appeared in the hall with the express object of watching me in this peculiar Olympics.

Once there, I stopped myself pretty much the way a beginning skater stops—by grabbing an ashcan. When I dared look up, there was Nick in his tux and flat shoes, moving through the world as effortlessly as I once had. "You look wonderful," he said, without seeming to notice I couldn't go anywhere. He left, after promising to introduce me to the mayor, and I was alone until two flowered ladies saw my getup and took me for one of them. I began to feel more at ease, especially as the waiters were now circulating with trays of champagne.

The room filled up. My feet started to ache. When it was so crowded that you couldn't see anything but shoulders and heads, I kicked off the heels, worked my hand into my purse, and dropped the flats one by one onto the floor. As I was telling the ladies my joke, about the group of dyslexic priests who get together to discuss that age-old question, "Is there a dog?," I snagged the pink shoes one by one, trying to pick them up with my toes. I was wearing nylons and they kept slipping, so I had to hunt around with my feet until I found them again, all the time chatting brightly with my two ladies.

When Nick reappeared with the mayor, to introduce me, I was barefoot, with two pairs of shoes at my feet, on my fourth glass of champagne, and telling my 9-year-old son's favorite joke, the one about why the ants were dancing on the lid of the peanut butter jar (because it said twist to open).

I enjoy being a girl.

69

Sinking into a Nice, Soft
State of Gloom

We keep forgetting, in this relentlessly cheerful age, that some days are meant to be steeped in a kind of gentle sadness. This is especially true in January, when the holidays have roared past, leaving only a handful of bills circling lazily in their wake and the lingering suspicion that life is a hollow joke.

This feeling of gloom is a vastly underappreciated state of mind. A natural force, it should not be chased away, but welcomed, like a light rain on the shutters.

If you're having a sinking spell, don't try to get over it.

Get into it.

A serious funk should take the whole day. Rig up some soul-splitting music, some Ray Charles or something from "Porgy and Bess." Wear your softest sweats, but take pains with your hair and face, so that if you catch sight of yourself in the bowl of a spoon you can allow yourself a wan little smile at the shame of it, a looker like yourself home alone.

In certain moods dust and disorder—nothing I would ordinarily notice—can push one right over the edge. Melancholy should not be confused with sloppiness; start by cleaning the house, not forgetting to take a toothbrush to the shower tiles, and mop up those stray hairs behind the toilet.

When every surface is gleaming, it's time to drag the electric blanket into the living room. Pretend you are terribly, terribly sick, so sick you must have a hot toddy with rum and lemon and honey.

Blast the heat and to hell with the PG&E bill.

Stack up all the books you've been meaning to read so they form a nice little drink stand. Then read T. S. Eliot and Robert Frost for a little while. Close the books with a sigh to stare out at the winter day, feeling sadness and self-pity pressing on your chest as if a refrigerator were strapped to it.

If you're blue because someone has gone, turn the radio to a station that particularly bugged that person and blast it.

Dip into the essays of Woody Allen, who said, "Life is full of miserableness, loneliness, unhappiness and suffering—and it's all over much too quickly." Remember that suffering requires a complex temperament: Chickens aren't known for their manic highs and lows, but whales, beasts of uncommon sensitivity, have sinking spells that displace continents.

By now you may be able to take a little nourishment. Think for a long time—this is important—about what you love most in the world to eat. Gorgonzola-stuffed quail? Graham crackers with blackberry jelly? Soft Brie on a pippin apple? When you have settled on what to have, cross town to get it if you have to.

When you have coddled yourself with poetry, toddies, an exquisite meal and Sahara heat for long enough, you might devote a final five minutes to contemplating a saying that my daughter Morgan's teacher tacked up in her classroom: "Practice random kindnesses and senseless acts of beauty"—a saying no less appealing for being a trifle incoherent.

Although it's unlikely you will be able to think of somebody who is more miserable than yourself, low-down cast-off-bag-of-bones-the-cat-dragged-in that you are, still, someone may come to mind. Bake him or her some nice hot bread (put the yeast in a glass first to make sure it's working) and take it over there.

If by now you have found that gloom has decamped, leaving you in an irritatingly cheerful sort of mood—impervious to poetry and ready to settle for a hot dog for dinner—at least you'll have had your nice day in the dumps.

You Can't Just
Get Rid of Your Past

W hen John, the moving man, said I would need at least 100 boxes, Bill said, "Do you really need all those books you've already read?" A book editor, he's less sentimental about them than I am. He sold part of his own unwieldy collection, and claimed it felt good to get rid of them.

I don't like to get rid of books. I don't even like to pack them, actually, because I may need them any minute. My junky, coffee-stained old books, mostly from secondhand stores, are my past. If I have ever read a book and liked it, if I have ever spilled coffee on it, carried it around in my purse, dreamed about getting back to it at boring dinner parties or defaced its pages with my pen, then I want to have it on my shelves.

It's not that I revere books, exactly. In my family, a book was like a paper cup—valuable only for what was inside it. We bent the pages down to mark them, sent them through the wash, propped up wobbly tables with them.

We even tore them down the middle, as my mother and I were forced to do once with *The Egg and I* when it was too much trouble for her to go find a book of her own.

Once, I was helping to paint our living room and couldn't get the last book out of the built-in bookcase, so I just painted over it. I hated to do it, not because it meant I was wrecking the book, but because it meant I was leaving it behind.

I don't give up books willingly, but for Bill, I tried. I got a big

cardboard box and stood in front of my shelves. Surely, out of hundreds, I could find a book or two I could live without.

How about this slightly damp guide to local architecture? No, I can't give that away. I have only to pick it up to remember the days when I worked at *SF Magazine* and had to pass myself off as someone passionately interested in interior design.

And here in its torn yellow jacket is my *Guide to Greeting-Card Writing*. I thought I would make my fortune with such gems as "You have bedroom eyes. Can I see the rest of the house?" Or my masterpiece: "Your new baby is beautiful. Is it adopted, or what?" The greeting card companies remained strangely indifferent to the reams of stuff I sent them, but they might come to their senses. Better keep this book.

My collection of French novels, my college textbooks, my spotty collection of California history, the set of 1948 World Book encyclopedias that the kids treasure so—how can I give them up? Every book reminds me of myself in an earlier incarnation, of a time when I actually wanted to read something called *A Complete Guide to Executive Manners,* or had decided to teach myself Spanish, or was determined to read all of Proust.

The truth is, I can leave this apartment I have lived in for two years without a backward glance. I can leave the manic green garden and the turtle we buried in it, dreaming of spring. I can plug the nail holes with Pepsodent, scrub the phone numbers off the woodwork, take down the basketball hoop, box up the groceries.

But I can't leave the books behind. Nora Johnson said you are changed by every place you live in, but for me books are places I have lived in. They are people I've known, pleasures remembered.

I have a wonderful essay about weeding out books around here somewhere. By E. M. Forster—in that paperback with the torn corner on the shelf in the bedroom. Or maybe it's by Orwell, I don't quite remember.

The important thing is, it's around here somewhere.

THE CAREER

▾ ▾ ▾

"My new plan is to skip ahead to the talk shows and the movie, and write the novel later."

The Making of a Jerk

I am starting to throw a lot of mail away unread. Why? Because I have moved into middle management, and I am increasingly aware of how rare and precious a commodity my attention is.

My underlings, in contrast, read all their mail. They're grateful that someone has taken the time to write to them.

The mail I do not throw away I read during my conversations with my staff. This impresses on them how many other claims on my attention there are at any given time, and thus how honored they are to be talking to me even though I am not listening.

If my subordinates persist in making their opinions known to me, I say, gently, "You and I are pretty far apart on this," which means, "Keep your unbelievably idiotic opinion to yourself, Jack."

If that doesn't quell the unwelcome onrush of objectivity, I add, meaningfully, "I'm not in the position I'm in for nothing. Give me a little credit for knowing my job." And then I smile encouragingly, skillfully reminding them of their own gross inexperience and making them bitterly sorry they bothered.

I am also learning never to say exactly what I mean – preparing for the day when I will no longer know exactly what I mean. I know less and less – remember, I am throwing away much of my mail – but it matters less and less.

Although I was promoted for the long hours I put in and my zeal on the job, I no longer do much actual work. The further you rise, the more it is to be assumed that you are working in invisible ways – when you are on the phone, or out to lunch, or staring out the window – even when you seem to be paying your bills.

Anybody can tell if my subordinates are working just by looking at them. If they're on the phone, they'd better be holding a pencil. If they're out to lunch, it's their lunch hour. If they're doing their bills, they're fired.

Sometimes I touch my subordinates on the shoulder as I lean over to inspect their work. They do not touch me – that would not do, just as it would not do for them to read their mail when I am talking to them.

I never have lunch with my subordinates, only with my peers or my superiors – those with the sort of inside information I need in order to continue clawing my way upward.

It is true that my bosses often try to get out of having lunch with me in order to have lunch with their own bosses, and I end up eating alone at my desk, but then it is lonely even halfway to the top.

I know what you are thinking. This person is a jerk. But I'm not really. I fought this transformation, just as your own boss once fought it.

More promotions mean more power, and power is corrupting. You fall a little in love with yourself – all the more so because there's no longer anybody around who dares to say, "Oh, shut up, Stanley" when you say something stupid. (This will work even if your name isn't Stanley.)

You must internalize this voice.

Just for fun, try it, all you bosses. Next time you find yourself mesmerized by your own voice, say, "Oh, shut up, Stanley."

The Night School of Hard Knocks

I t was the second day of the fiction class that I had paid $165 for and given up my Thursday nights to take.

An upset at work had made me rethink putting all my eggs in one basket, and I had become obsessed with making my fortune by writing a novel. (I know I'm not the first to get this idea. I try not to think about Erma Bombeck, who once said to a man, admiringly, 'When did you first get this idea for not writing a book?')

But I had no idea how to do it. A night class, I decided, would be just the ticket, allowing me to share my first secret stumblings with a sympathetic group who would sip machine coffee out of Styrofoam cups while listening appreciatively to one another's efforts.

I would mention the encouragement of this group when the paperback edition of my novel sold to Bantam for a record amount.

The first class went well, and at the end we got our first assignment—to write the plot outline for whatever opus we were working on, and bring it in for class discussion.

All week, I slaved over my outline. I had had the strikingly original idea of making my first novel largely autobiographical. About my childhood, in fact. I deftly interwove all the elements covered in the first class, not forgetting conflict (the day Dad burned down our house for the insurance and found out too late it had lapsed) or foreshadowing (even our dog, George, left us for a family down the street). Then I made 24 copies on pink Xerox paper, one for each student.

The second evening was stormy—we had moved suddenly from summer to winter—and we had dropped to 16 people. "The real

writers, like snails, come out in the rain," the teacher reassured us. She returned the enrollment slips she collected in a burst of administrative fervor the first day. "I'm sorry," she said, "I had a deep need to collect something."

By 8 o'clock everybody was half asleep and doodling while the teacher completed a discussion of suspense, to which she had added some of her own by trying to open a can of Diet Coke with her long red fingernails. The struggle lasted for almost two minutes.

Then she asked for volunteers to read their outlines, and I, not having learned that much yet and determined to get the most mileage out of my $165, read mine first. When I finished, there was a stunned silence.

"Can we really be brutally honest?" asked a distinguished looking man in the back row (actually, everybody was in the back). He was there, he had said, to collapse five novels into one on the advice of his agent. "You had one or two interesting characters, but your novel bored me. The last thing I want to be dragged through was that little girl's childhood. It picked up for me in the scene where Casey almost ladles her grandmother's ashes into her coffee."

The scene with the ashes is the second to last. I wadded my coffee cup until it was the size of a quarter, keeping a smile plastered on my face.

"Can't you make the childhood a sort of prologue?" asked a young man in the seat ahead of me. He wasn't even in the class, but had come to tape it for his girlfriend, who was sick.

"I don't understand what it's about," said a blonde woman across the room. She leaned over to make eye contact with me. "What I'm wondering is, what about it is *new*?"

"You're next," the teacher said to a man sitting at the back. There were lots of hands in the air.

"I can't be next," he said. "My hearing aid has broken and I can't hear a thing, and I'm very frustrated." He got up and left.

I was squirming in my seat. This was the story of *my* life they were talking about. I brought out my big gun. "I sold this idea to Doubleday," I said. "They want to hear that story."

The class suppressed a collective yawn. They listened politely to

this, the most exciting thing that had happened to me in a decade, and then dove right back in. "I agree with the first man," said a woman at the back. "I don't want to hear about the childhood. Nothing happens, and the characters aren't very interesting."

That seemed to sum it up for everybody, and we went on. Jose, a medical supply salesman sitting at the back, with a halo of curly black hair, read the outline for his novel next.

It had enough plot for six books. Every few minutes a trainload of people would be herded out and shot, and then another generation would grow up, move to Texas or L.A. to start a restaurant, and then some more people would be herded off a train and shot. Or so it seemed. The class didn't ask Jose a single question, and the teacher said only, "You certainly have a fine sense of drama."

At the end of class, three or four people followed me out to the parking lot to renew the attack on my plot. Several of them were apparently going to lose sleep at the thought that somewhere, some-day, that tedious childhood might find its way into print.

The assignment for next week is to revise the outline. I'm going to put some trainloads of hostages in mine—maybe get them at the local night school—and have them all shot by bandits.

▼ ▼ ▼

An Author Doesn't Have Time
to Write

I t's not a wildly original idea. Go up to anyone and say, "How's the book coming?" and they'll look dumbfounded and stammer, "How did you know?"

If you try this with me, I will burst into tears. The advance for the book I'm supposed to be writing sits in front of my door, a black Toyota ready to whisk me off to literary lunches and book signings. But my deadline has come and gone like the wildflowers of spring and there is no book. I don't know how to write it.

I do know what it's supposed to be about, because it's right here in my contract: "Said novel shall be the story of a wild Irish family . . . " It also says it's supposed to be 92,000 words long, but I think they must be kidding about that.

None of this was my idea. What happened was, my agent was shopping my columns around New York, and all the book editors looked up from their martinis and snarled, "Jesus, Bob, humor columns don't sell, for Chrissake. What else have you got?"

But one day a wet-behind-the-ears editor at Doubleday, impatient to dive in and start making mistakes, said, "The others are right, these columns are awful, but would she write a novel, maybe about her crazy Irish father?"

Would she? Would she *ever*.

On a bright clear Saturday in early fall I snapped a new ink cassette into my printer and started to type. It was all going in—the layer cakes Grandma studded with toothpicks to hold them together,

Rodney Dugan's unfeeling behavior to me when I was 8, what a wonderful child I was, all of it.

Months went by, fall giving way to winter, winter to spring. Saturday mornings found me staring unhappily out the window or hanging motionless from the open refrigerator door, as if one more sight of the leftover tuna fish would prod me into genius. When my editor sent me a cheery Christmas card saying "Best wishes to you and your prodigal father," I wanted to write back saying, "Quit bugging me!"

It was slowly dawning on me that I had no idea how to write a novel. The dawning was slow because I figured that Doubleday must know what it's doing. If it thought I could write a book, who was I, an obscure hack from San Francisco, to say it was wrong?

After 10 months, I had a couple of paragraphs that I was pretty happy with. I don't know how other writers work, but this seemed a little slow. I began to think about giving the money back.

Then one day I switched on the TV and saw an author chatting urbanely with his hosts on "Good Morning America." It came to me in a flash that I was going about this all wrong. What I really should be doing is honing my talk show lines and familiarizing myself with subsidiary rights. Attempting to do the actual writing is threatening to put a crimp in my career as an author.

My new plan is to skip ahead to the talk shows and the movie, and write the novel later. Reviewers might point out that the prose seems a little spare, but I doubt the talk show hosts will notice the difference, especially as I am prepared to be winning on camera, and to candidly name the real-life figures that my cruder characterizations are based on.

If I can sell the paperback rights first, and then negotiate the movie contract, someone else will write the screenplay, and there'll be the novelization after that. With those two in front of me, it should be a breeze to dash off the book itself, if I can squeeze it in between the Geraldo Rivera and Phil Donahue shows.

▼ ▼ ▼

Beginning, Muddle and End

T he other day my 5-year-old nephew, Tony, was complaining
that his sister wouldn't give him back his toy Batman. "Lean on
her a little," my brother said, and so Tony went over and leaned on
Katie until they both fell over.

I mention this because my publisher, Doubleday, is leaning on me.

My agent, Bob, is very depressed. "Adair," he said, taking a deep
breath, "I can't hold them off any longer. You have to give them
something by Labor Day, or we call the deal off."

By which he means, of course, give back the *money*.

That scared me. I got out the contract. It's dated October 1988,
and says something about "growing up in an Irish family . . . way-
ward father. . . . First half to be delivered May 1, 1989."

So here it is only August 1990, and already they're demanding
to see something.

While they've been waiting, I've been discovering it's one thing
to say, "Yes, you bet, write a novel? Sure thing." It's another to sit
down and write one of the wretched things.

Friends were helpful. Mark was enthusiastic about the few
moribund paragraphs I showed him, which only made me question
his sincerity and his judgment. My friend Annie Lamott (you have
to read her book *Rosie*) advised me to write a terrible first draft,
which I did—or part of one, anyway. That's another reason my agent
is so depressed.

Yet I want to do it. On good days, I even think I could do it,
if I tried. You know the feeling. You have a project yourself, I know

you do. And you have lots of good reasons why you can't start right now, too, don't you?

So do I. I'm waiting for all my relatives to be dead. Novelist Annie Dillard says she lets her relatives read her books and take out anything they don't like. Dillard's last novel was a description of the landscape.

I tried to cheer myself up by snipping the few sentences I liked out of my horrible draft and pasting them to yellow sheets of paper. I wasn't doing any writing, but was convinced I was hard at work on the novel. Unfortunately, my art project kept getting interrupted by writer friends calling up to say, "I'm up to 46,000 words today. It just *pours* out of me."

When I told my friend Jerry I was blocked, he very meanly quoted G. K. Chesterton, who said, "The artistic temperament is for amateurs."

So, OK. I'm willing, sort of, to stay home the rest of the summer, trying to type around this cat in my lap. But it'd be a comfort to think I wasn't the only one missing all the fun—that you, too, were starting that project you've been dreaming about. The one you kind of suspect you could bring off, no-talent spineless worm that you are, if you just sat down and did it.

Then write and tell me about it, so I can add yours to the irritating tales of triumph I'm already getting.

The Value of a Job Well-Undone

Recently I complained about how unreasonable Doubleday was being in demanding a manuscript from me after I missed a trifling three deadlines.

When I wrote that column, I was still laboring under the impression that I ought to buckle down and write the damn thing—that it would be good for my soul and an inspiration to others bowed under the weight of their own unfinished projects.

Then I heard from readers, in two distinctly separate batches.

The first batch, which arrived promptly after the column came out, was full of encouragement and good advice. "Shut up and write," they said.

The second batch is still arriving. All of the letters show signs of having been carried around in a briefcase before the writers got around to mailing them. All were much lengthier than they needed to be.

These were from my people, those who agree that if a thing is worth doing, it's worth putting off.

"I read with keen interest your column on the novel you are not writing," said Max Immel of Daly City. "There are so many wonderful things to be not doing. I've been not studying German for months now. I'm thinking of switching to Spanish. They tell me it's a much easier language to not learn."

Other readers are busy not finishing Dad's needlepoint surprise ("Mom says it's my way of sticking it to him"), and not testing cookbook recipes. Ben Sevdy sent me a Christmas card ("just getting that out of the way") to say he's not overhauling the classic old BMW that

was still running when he parked it in his Chico yard a year ago. And Stephen Miller of Oakland, cursed with an interesting day job, is just putting the beginning touches on a detective story.

I found something to admire in each of these tales, but what really got to me was the way Stewart Port, also of Oakland (hotbed of activity over there), tossed aside his overdue technical booklet to sit right down, seven or eight weeks after my column ran, to write a single-spaced three-pager pondering the nature of procrastination.

Stewart's theory is that if we're not doing what we're supposed to be doing, *there's a reason*.

"It's as if the undone task, the potential achievement, has more value than the completed task—that the 'going-to-do' is some treasure that would be spent in the doing."

A treasure that would be spent in the doing. I thought only the Irish could come up with an excuse as brilliant as that.

You see the beauty of it. If you have a Beemer awaiting overhaul, a needlepoint needing stitching or a novel needing writing, *suddenly life has meaning*. Suddenly, every idle, wasted moment is charged with a strange and compelling joy.

If I didn't do much on my novel in August, despite certain rash and public promises, it was surely because in my soul I knew better than to *spend* this treasure, this overdue pile of yellow manuscript that brings a sweet urgency to everything else I do, from emergency toning at the Claremont Spa to collecting my favorite rock songs on one tape, to collapsing in the back yard next to a speaker run out from the kitchen.

There will be consequences, of course. They can take back the advance. They can even, conceivably, take back the car I spent it on.

But they can't take back the joy that comes from a painful duty being ignored. In the unlikely event they ever succeed in spoiling everything by wresting this book from me, I'm going to take up needlepoint.

Working at Home
Is No Couch of Roses

W orking at home, when you're used to an office, feels at first like being shoved out of a moving car. You hit the pavement hard, and the car speeds away, taking with it your former co-workers. They're drinking champagne, discussing the boss' sex life, admiring one another's outfits, without you. They don't even notice you're gone—at the most, someone feels a breeze, and pulls the door shut.

I work at home a lot of the time now, and it's taken me awhile to get used to it. At first, every day stretched out like a long gray corridor. The fridge developed a sibilant whisper. For the first time, I not only remembered when the Alhambra man was coming, but I also planned what I would wear.

Sometimes I would vacuum the corn flakes off my sweat pants and bike down to the paper to work there, but it wasn't like my old job. Nobody called a meeting, or put work on my desk. All I heard was the tapping of keyboards. No one noticed the nice outfit I was wearing.

I would slink home again and call up my friends at their jobs. They could be counted on to sense my longing for human contact.

"What are you complaining about?" said Jane, the gentlest of my friends, in a voice etched with acid. She could only talk for a second because she had some pointless meeting to go to. "So what if you're lonesome? You get to work at home!"

Accepting, finally, that no one who gets to work at home even part of the time will have any friendships not destroyed by envy, I find excuses to go hang around my old office.

Everybody there has come to hate the sight of me wheeling my bike in. They ask me, bitterly, what the weather is like outside. They ask what I did that morning. They don't believe me for a minute if I say I was working, any more than *they* would be working if they were home.

"It must be nice," they hiss, "not to have a boss looking over your shoulder."

I smile at this, wanly. It's true that I had some problems with my old boss, who didn't even understand my need to run errands during the week so as not to clog up my Saturdays. She said I had an attitude problem, which was not true. I just didn't like being told what to do.

But now that I am, for most purposes, the boss of me, I find I work for a more unreasonable person than ever. She doesn't care when I run my errands. "Just leave your work on my desk on your way out," she says, grinning evilly.

In the office, it's true what they say—half of life is just showing up. You can arrive smartly at 8 a.m. and start paying your bills and gossiping on the phone, and if there's a pencil in your hand your boss will beam at you through the glass.

I tried just showing up in my living room. No one noticed. I marched myself smartly back to bed. No one noticed that either. At home, as in life, the time you waste is your own. You get paid when you get something done—a concept that would cause terrible suffering in most offices.

The rest of your time, whether you're staring dully at the screen or checking to see if your face still looks the same as it did an hour ago, are not billable hours. They're your vacations, which you now take in 15-minute increments rather than a week at a time.

They say that pretty soon a quarter of us will be working at home, so I should add, it does get better—a lot better. You learn to break up your day with lunch dates that give you a reason to get dressed. You do your work. You depend on yourself.

And in time you even stop bellyaching about working at home, because nobody wants to hear it.

THE FAMILY

▾ ▾ ▾

"Your family is like your hair after the rain. You can't do a thing with them."

▼ ▼ ▼

We All Do This, Don't We?

A while ago, my mother gave each of us kids, as our birthdays rolled around, a photo album of our pictures, from babyhood on up. When we got ours, my twin and I fell into a heated argument because I was going through mine and tossing out some pictures I didn't like.

"You can't do that," Adrian exclaimed. I had given the heave-ho to a particularly appalling snap of myself grinning in a bathing suit in the back of a pickup truck.

"You have to put that picture back," Adrian said, picking it out of the wastebasket and trying to smooth it out. "It *happened*."

"No, I don't," I said, snatching it back and tearing it in two. "Watch this."

Another time, a boyfriend said to me, before I could tell him again about turning 21 in Paris, "You tell the same stories about yourself over and over, and you never change a word."

What I needed, I eventually realized, was not new stories, but a new boyfriend to tell them to.

OK, OK, so I edit a little, when it comes to stories and pictures. When it comes to my life. Am I the only one who does this? Don't you, too, tell the same stories to new friends that you told to old ones? Aren't the stories funnier, sharper now than when they actually happened? And haven't they *become* your life, the novel you carry around in your head?

People sometimes ask me, "Did it really happen the way you wrote it?" The answer is yes and no. Everything I write about actually hap-

pened, and everything I write is false. You can't write anything the way it happened. A one-minute episode would run to 20 pages.

When I researched the history of Petaluma for a book, I found that I had thousands of facts I could shape any way I liked. The facts were true, but I could, if I wanted, shape them to make something false. The sequence that I finally arranged them into is just one version of the life of that town, one of thousands possible. Is it true or false?

This is what my dad is afraid I will do in the novel I am supposed to be writing about him—arrange the facts like pictures in an album, discarding those I don't like, and coming up with something false.

I repeated in a letter his story that he sometimes stands for 15 minutes before he can pee. He read it, then said, "I remember telling you that story, but are you sure you got the tone right? Remembered the point I was making? You are free to tell anyone on earth your poor old father stands like a stork beside a pool with no fish when he has to take a leak—but *get it all*."

Even a therapist I talked to had a great interest in restoring to me the lost stories, the childhood ones I have discarded, unconsciously and on purpose. This—getting those stories back—is known as mental health. She warned me, though, that therapy might change the way I saw my childhood—might in fact sabotage my book.

This reminded me of something I had clipped from the *New Yorker:* "The therapy of psychoanalysis attempts to restore to the neurotic patient the freedom to be uninteresting. . . . It is the denovelization of their lives."

Is the choice between truth or art? Between being boringly honest or thrillingly false? Do we blurt out everything that ever happened to us, include even the unflattering pictures in the album? Or do we select our stories and pictures, choose how we will present ourselves, making art from chaos? Don't we lose a lot, either way?

I don't know. The question seems important, but I don't know the answer. Maybe I'm just mixed up about the difference between writing and real life again, getting all defensive and Irish about it. I'm going to go to my room and cool off.

▼ ▼ ▼

Just One Day a Year,
Try to Be a Family

I don't know what Dad expected, showing up for Christmas after two decades of running into his children in odd places and having to take wild stabs at the names of the grandchildren. Whatever it is, I don't think he got it.

It was two years ago. Five of the seven of us kids were at my house, with our families, amid the usual chaos. Every year we resolve to open the presents one at a time, and every year it dissolves into the usual free-for-all, with everybody diving under the tree at once, grandkids lost somewhere under the wrapping paper, and in-laws looking on in a daze, until their own gifts come flying through the air to swat them in the chest.

I had stepped outside for some air when I saw him. He was cruising slowly down the street in his old panel truck, his little dog Fred posted at the passenger window, as if it were Fred's job to squint at house numbers.

The truck lumbered to a stop, and my dad spilled out. I hadn't seen him in a year or more. "How's tricks, Dare?" he said, as if he had been out for cigarets. He was unshaven, rumpled and swaying noticeably, although it had been seven years, at least, since he stopped drinking.

"Hey, Dad. Merry Christmas." I was glad to see him, but wary, the way all us kids are with our unpredictable father. I liked him more at the safe literary distance of our correspondence.

He had been living in his truck in the Mojave Desert, reflecting, reading and writing the brilliant journal he sends to me, but the

desert had grown vaster and emptier at Christmas time, even for him.

He had not so much fallen off the wagon as thrown himself off, to gird himself for this homecoming. It had taken him a week, drinking, coaxing that 50-year-old truck along the verges of the freeway, burning his books in the truck's stove for warmth, to make the journey to my door.

I led him upstairs. You never saw a place empty so fast. Brothers and sisters out the doors, in-laws out the windows, grandkids shooting up the chimney like sparks. "Well, Dare, give me a call later," Mother said, and she was gone. "Hi, Grandpa," my kids said uncertainly to the beery stranger standing in their kitchen, and then left with their own father.

In no time, it was just Dad and me, sitting in the kitchen as it grew dark. Out the window, the lights of the city winked on. Behind each I imagined a family, trying hard to get along at least one day a year, inarticulate with love and disappointment and the cruel season, the accidental ties of blood stronger than the thousand yowling arguments that dragged them apart.

Dad wanted to talk, and wouldn't even let me clear away the wrapping paper flooding the room like a Technicolor wave. "Stop that," he said. "How often do we see each other?"

Not often, Pop. Those were the choices made long ago.

We talked, and he told me things I had never known, about his childhood and even about him and me. I listened, and realized how glad I was to have him home for Christmas.

Now it's two years later, and in four days, it'll be Christmas again. I'm angry with my father again—he said some harsh things in a letter—but I'm going to try to get over it, and go out to Marin to find him.

If I can do it, you can, too. Forgive whoever it was—mother, father, son, daughter—who let you down this year. Your family is like your hair after the rain—you can't do a thing with them, so you may as well love them as they are.

Pick up the phone. It won't cost you a thing. It's the phone calls that don't get made that'll cost you.

I'm Going to Miss Having a Twin

"**N**o woman should ever be quite accurate about her age," Oscar Wilde said. "It looks so calculating."

I couldn't agree more. Every woman has the right to choose the age she feels comfortable with, rather than tediously counting the number of times the Earth has circled the sun since her birth.

Every woman has the right, that is, except me. I have a twin sister, an extremely pigheaded and uncooperative one, and if we agree on nothing else, we must agree on how old we are.

But we can't.

Tomorrow is my birthday, my 37th. Not to boast, but I think I have accepted the passage of the years with a certain grace, a certain readiness to embrace the blessings of maturity.

I wish I could say the same for Adrian. She is turning 38 tomorrow, and not a bit gracefully. She goes on pathetically shopping for size 4 jeans in the juniors department, and, sadder still, fitting into them. She pays no attention to the nice powder-blue ladies' polyester suits I try to interest her in.

Most annoying is her pedantic insistence on adding another year to her age, just because a year has passed. If she keeps doing this at the present rate, we'll be forty in two years.

I told her I had decided to stick with 37 for a while, as I was just getting used to it. I said it would look a lot better all around if she did, too.

She said no. She wouldn't budge even when I pointed out that

having a twin a year younger was going to be an inconvenience for her. It suggests an inattention to detail.

It also suggests a nightmare labor, which wasn't the case at all.

We were born 10 minutes apart, Adrian first. She always said she was the real baby, and I was a kind of backup.

She may have been right, because only one was expected. The intern at the hospital was heading for bed after delivering Adrian when a sound made him turn in the doorway. "What're you doing?" he asked. "You just had your kid."

It was 1952, year of siren sheaths, ponytails, hot rods, and flying saucer sightings. Mother brought us home to Stinson Beach 10 days later in a cardboard box. We met our three siblings, Sean, 4, Connie, 3, and Mickey, 2, who piled 14 blankets on us because "baby cold." The *Stinson Beach News* wrote Mother up for having five children under the age of 5, her mother asked her if she had ever heard of birth control, and the landlord gave us 30 days to get out.

These early trials drew us together. You can't share a cardboard box with someone without feeling something pretty special for them. Go ahead—try it.

We had older sisters—who don't enjoy that term as much as they once did—and eventually a younger one, but being twins was a different feeling.

When I was little, I was convinced that I would expire exactly 10 minutes after Adrian. I wondered how it would feel, being alone for those 10 minutes, my twin gone. As writer Gregg Levoy commented, others are born separate and must learn intimacy, but twins are born intimate, and must learn separateness.

I don't want to learn too much separateness. On the other hand, I'd like to sneak up on 40 a little more gradually.

So there it is. I'm going to miss having a twin, now that Adrian is just another big sister. It was nice, having a companion through life. The best part about it was that no matter how old I got, there she was, my twin, my mirror, getting just as old—and even 10 minutes older.

Lady Bug, Lady Bug,
Fly Away Home

I was teetering on the edge of bankruptcy. The kids and I were playing Monopoly, with money and properties spilling all over. Land-poor, the victim of an ill-advised spending frenzy, I was hitting everything on the board, from the slammer to Morgan's slum housing on Baltic Avenue to Patrick's shiny red hotel on St. James Place, on which I had landed for the third straight time.

"How about a discount because I'm your mom?" I begged, but the little tycoon only flipped over my cards, showing me how to mortgage my paper empire.

"Did they have Monopoly when you were a kid, Mom?" Morgan asked.

It's difficult to remember back that far, but it seems to me that I spent my entire childhood on the floor, landing on other people's property and handing over exorbitant rents.

Playing Monopoly reminded me of my dad, who always seemed to be nervous about the prospect of owning a house. His goal in life was anything but to "become the wealthiest player through buying, renting and selling property," which is the object of the game.

His object, at least one night, was to become the wealthiest player by burning down the house, Monopoly game and all. He had read somewhere that anybody can get away with it once.

We lived out in Lagunitas then, in West Marin, a family of nine living on the earnings of a carpenter who worked only in good weather. Mother spent entire evenings going over the bills, deciding which ones we could afford to pay, while Dad stayed down in his

workroom, welding things together and dreaming up schemes for getting us out of our financial hole.

One day he ran an ad in the local paper: "Shoddy Work, High Prices." When nobody called, he must have decided somebody had to light a fire under this family. And that somebody was him.

Chivalrously, he had not told Mother what he was up to, not wanting to involve her (and also wanting credit for his brilliant scheme himself). We had all gone to bed ("I had every one of you spotted," Dad told me later) when he came up from his workroom and asked Mother, very casually, if she smelled something burning.

"Yes, smells like a short or something," Mother agreed. Dad ran downstairs, ran back upstairs, then rousted us out of bed. We spilled into the dark yard, wildly excited. Flames licked out of the work-room door. When mother lunged for the phone, Dad said, "No! Let it burn. We'll collect the insurance, start over somewhere else."

Mother just stared. "Don't you remember? That was one of the bills we decided could wait."

Dad lunged for the phone himself then, and minutes later the air filled with sirens. The house was saved, although Dad's work-room was a sodden, charred mess.

"Sometimes," he confided to me much later, "I think your mother might have almost lost patience with me."

I still haven't puzzled all this out. Something in me wanted that fire, too, wanted it to eat right through the walls and the mattress and my koala bear with the stuffing coming out.

And here I am, all these years later, still losing at Monopoly, still landing on other people's property, handing over outlandish rents. Sometimes I think I should own something by now, even if it's only a little flat over on Baltic Avenue, on the wrong side of the Reading Railroad tracks. But reverence for property doesn't seem to be part of my birthright.

I did learn something from my father, though. I pay my bills on time.

▼ ▼ ▼

The Daly Kids: the Sequel

My sister Mickey's daughter is getting married, and somehow the whole thing just snowballed. First just a couple of us were driving up, and maybe one or two flying in, and now it seems we're all going, all seven kids, gassing up cars, trucks, a borrowed motor home, a surfer van and one second-hand Beamer to cross the alien landscape of the Pacific Northwest to Mickey's house in Idaho.

It's been a good 20 years since we were all in the same place at the same time (good maybe in more than one sense). Sean, 42, bailed out first, heading for the tiny town of Colville, Wash. I know it's irrational, but I'm flying to Idaho because I'm afraid if he sees my car he'll make it into a go-cart.

Mickey, 40, lit out second, heading up to Coeur d'Alene, Idaho, with her kids. She just bought a house up there this year with some money left over from a trip to the grocery ($31,500 for a three-bedroom house on the lake), then found some change at the bottom of her purse and bought the lot next door ($12,500). The golden-haired child whose only wish was to be a nurse, she's now the manager of the Pine Shed, the rowdy local tavern, where we'll all get to go, even Connie, maybe.

Connie, 41, clung for years to the idea that she was a refined foundling left by mistake on a working-class Irish doorstep. She'll motor up from Salt Lake City, making a rare personal appearance since she decided several years ago to regard Mother as just a friend. We all promptly decided to regard Connie as just a friend too, only as one we didn't like very much. Mickey used to offer to come down from Idaho and punch Connie out personally.

Now Connie's got her head on straight again, and we all like her. I actually feel more secure with her than with Sean, because with Connie there's no uncertainty: It's not whether she'll cause trouble, but how soon, and in what way. She once wrecked a trivia game when she insisted that Indonesia was in Africa and refused to budge even when confronted with the map. To this day she asks odd questions, like why we aren't we playing Jeopardy by the rules and is anybody checking on the food and when does the Pele dancing start.

Those three are the Big Kids, as they were always called. The Little Kids—me; Adrian, my twin; my little brother Shannon, 36; and our even littler sister Robin, 27, will be coming from the Bay Area.

Dad won't be there, of course, unless he gets wind of the reunion and decides to make one of his electrifying surprise appearances. Mother and I are flying up together. I hope for her sake we won't revert to our collective childhood obsession, which was trying to get into her lap and stay there, cutting our eyes at the others left far below on the cold linoleum.

The real question is, why would seven people cross several states in the heat of summer to see people who once wouldn't have crossed the room to throw a drink on them if they were on fire? Are we all tired of finally being able to get into the bathroom?

Could have to do, maybe, with the way we all came roaring out of childhood, each tilted a different way. Now that we're piling up on both sides of 40, running into walls and saying, "What the hell . . . ?" we've begun to talk to one another, just a little, retracing our steps in fits and starts. It turns out everybody remembers the awful day Dad tried to teach us to water-ski—and slowly, slowly, the Irish conspiracy of silence gives way. We start to find one another, as if in a dark room equipped with a dimmer that someone is slowly turning up.

The Dad Who Ran Away
from Home

My dad turned 68 a couple of months ago. I didn't send him a card because I don't know exactly where he is – probably somewhere in the Mojave. He is trying to find himself, and I guess I am trying to find him, too, after all these years. He's mad at me again, I think. It's his turn. For years he and I have had a war of words, a blizzard of letters crisscrossing California as we struggle with the forces that push us together and pull us apart.

Dad refuses a relationship based on the dadness of him, on what he calls "little cosmetic pats for the sake of convention." "You have the power to hurt me, so I must care, mustn't I?" he scrawls on a yellow sheet. "Maybe, just maybe, I'm not descended from Irish kings after all, but I'm more than a vacant face dandling a baby on its knee."

We have the power to hurt each other. That's what our letters are about – I do want the dadness of him, and he has devoted his life to thwarting expectations, mine and everybody else's. He is bitter about my defection to the middle class, and I am impatient with his harsh judgments. But we keep writing, each letter bringing a heated retort – and a glimmer of understanding.

We never thought he would see 60. My sisters and brothers and I grew up in the San Geronimo Valley in Marin County, an unruly Irish family that other children envied and other parents moved away from. Dad stayed until I was about 10, when he was carried away on a high-cresting wave of Schlitz. For years, he periodically hung himself out to dry at Napa Hospital, like a sleeping bag that fell

in a stream. "I have made some 20 trips to mental institutions," he said. "I can't imagine why I did it. I must have been crazy."

One day he stopped drinking—said it no longer agreed with him—sold his carpenter's tools and headed out for a life on the road. He lives in his truck, a derelict green panel '53 Chevy that comes breathing hard down the road like a piece of billboard that somehow detached itself. What social life he needs is provided by the cops who drop by the driver's window to discuss the vagrancy laws with him. Dad says people ask, "What do you do for a bathroom out there?" and he says, "I have a pretty slick system—what about you, what have you worked out?"

Before he left the valley, we kids used to steal out to see him on the ranch where he parked his truck for a dollar a day. We brought our jobs, our new cars, our promotions, dropping them in his lap like a cat dragging in dead bird after dead bird, waiting for the praise that never came.

He isn't unduly worried about what I or anybody else thinks of him—claims the world needs a few nuts amusing themselves in the backwash. "In a country dedicated to rampant economic gluttony," he wrote me, "a few granary mice are unavoidable."

For a while, the loneliness seemed to be getting to him. In one letter he said, "Having run out of everything else, I am now toying with the notion of sainthood as bait no one can ignore. A full-fledged saint living in a broken-down truck by the freeway, having miscalculated again."

Dad's doing fine, reading books, writing, watching the chipmunks chase one another outside his window, their tails wagging like metronomes. He didn't die of drink, and now is coming hard up on his three score and 10, every hour of it spent watching his fellow men with one eyebrow lifted, not noticing, never noticing, that his shirt gapes and he is wearing bedroom slippers again. "Make a wonderland of your own bog," he tells me. "It's the only way."

▾ ▾ ▾

Home Sick and Homesick

T he sad truth is that there is no point to getting sick when you're a grown-up. You know why? It's because being sick is about you and your mother.

It's not like when you were little. Getting sick then meant a trip to The Couch, the sagging green one. There, propped by pillows and blankets, comforted by your mother's cool hand on your sweaty little brow, you entered an infinitely gentler world, the mysterious one your mother inhabited when everybody was off at school.

In this world, the pace of life slowed down to the buzzing of an insect out in the yard and the sound of your mother clinking glasses as she dried them and put them away. It was a world without brothers and sisters. In this world, Neapolitan ice cream—ice cream someone has made a special trip to the store to buy for you—melts on your tongue, tasting slightly of the metal spoon because you are eating so slowly.

To get to this favored spot, you sometimes had to let your head loll rather obviously on your arms at the kitchen table. Other times, though, your mother would notice you dragging the broom across the floor and ask you tenderly if you felt all right. Once, when the seven of us kids were all hanging around the house, mother said, "Shannon is really sick. Look at his eyes." We all looked at my brother's stupid eyes. They looked fine to us—maybe a little glazed, but wasn't that normal, at least for Shannon?

Ten minutes later, he was installed, grinning, on The Couch in his GI Joe pajamas while mother bent over him adjusting his pillow and the rest of us stood in a hot, jealous knot, watching. Shannon

was trying to talk around the thermometer, insisting that he didn't want to miss the math test—all the time cutting his eyes at the rest of us.

Nothing like this happens when you grow up. If you suddenly find yourself wincing at the glare from the computer screen or the roar of the pencil sharpener, you still feel that thrill—"Yippee! I'm sick!"—running like a song underneath the discomfort. But then nothing good happens. Unless your mother happens to be at the neighboring cubicle, there is no one to say, "Gee, honey, you don't look well. You better come lie down."

Without that solicitous hand on your forehead, there is no one to confirm that you are really sick. Already miserable, you now have to feel like a goldbricker, telling your boss you're not feeling well when you look the same as always, and it's a nice sunny day outside, possibly on a Friday, maybe even the day before a three-day weekend, and how is he to know that you're not making it up? So you skulk out, with everybody wondering where you are really going.

You stop at the corner store to stock up on aspirin and soda, and then stagger sulkily around your apartment for the rest of the day, washing up the dishes or staring blearily at the bookshelves. You're dizzy and the colors in the room hurt your eyes, but you still wonder whether you should mop the floor or something, as long as there is no one to see how sick you are anyway.

Mothers cut right through that. "What are you doing up?" they say, drying their hands on their aprons, hustling you back into your warm covers. "Now you stay here. I'll bring you some ice cream." Sometimes she even turns on the TV. You want your mother, and no one else will do. Boyfriends say, "Oh, sweetie, that's too bad," and offer to pick up something from the drugstore, but they always forget.

Children are even worse. All children live in fear that someone else will think of getting sick before they do. As I lay in a pool of wretchedness on the couch, explaining to my daughter Morgan, 10, that I had to come home sick, she pointed out that her own stomach had not stopped hurting for a whole week, and nobody let her come home. "I'm so sick I'm sweating air," she said. Then she asked if I would make her a sandwich.

So, nothing from the boyfriend, zip from the kids. It is beginning to dawn on me that now when I get sick, I am just sick. Not special, just sick. Once childhood is past, there is no sagging green couch, no pot-bellied stove, no brothers and sisters to wheedle a bite of your Neapolitan, no mom to insist that you stay home with her. There is no point in getting sick at all, anymore, unless it really is a sunny Friday and you want to beat the crowds up to the lake.

Twin, Friend,
Inseparable Opposite

M y twin sister, Adrian, who lives in Ukiah with her husband,
calls me up practically every day to say, "We've found the per-
fect cat for you. I brought him home, and he's just here, waiting."

Adrian and I are very close. I have accepted her apparent wish
not to have kids, bugging her about it only once or twice a day now.
But I don't think she has ever really accepted my decision not to have
pets. I think she's convinced that I'm just being brave, and clinging
to Morgan and Patrick as pet substitutes.

The reason she insists is that, knowing the joy of owning a dog,
she wants this for me. And it would give us something to talk about,
now that our lives are so different. I want her to have a baby for the
same reason.

People expect twins to compete, and I guess we did. When we
were born, three weeks early, Adrian weighed two ounces more than
my svelte 6 pounds even, but it was the only time she ever weighed
more. I figure she starved herself, that whole first day, to get those
two ounces off so her sleepers would look a little tight on me. She
has weighed five pounds less ever since – if I went down to five
pounds she'd go down to zero, just to stay ahead.

Maybe it was partially because Adrian was prettier that I went
all out to please, earning good grades and obeying all the rules. I
didn't realize what effect all this toadying was having on my twin
until the sixth grade, when I was caught leaving Lucky supermarket
with a bag full of Good 'N' Plentys I'd neglected to pay for.

"I just went into shock," Adrian told me years later. "I thought

if Adair could steal, then anything could happen. The world had become an unpredictable place."

By high school, we were moving in different directions. She hung out by the football bleachers while I was doing my homework and sometimes hers as well. I would try so hard in the broad jump that I couldn't walk the next day, and still do no better than all right. She'd wait to have her name called three times, then saunter up, break the school record, and duck back behind the fence for a cigaret.

After high school, I went to college and moved to the city. We still got together a lot, especially when one of us was dashing off to Reno to marry somebody or other. We treasured that special bond between sisters that comes from always being present at each other's biggest mistakes. Her second husband was Jack, a good-looking reserve cop who ran with a law enforcement crowd. He let her apply to be a guard at San Quentin when she promised to marry him. That lasted a year, during which the cons passed her notes, advised her to smile more, and struggled to get into her line for the body searches.

Meanwhile, I had got a job as a copy editor, where the most dangerous task was calling up Herb Gold to say, "Listen to this sentence and see if you can live without the comma."

Adrian became a deputy sheriff and is now the civil clerk in Ukiah. Her husband, Bob, is the dogcatcher there. He pins notes to his favorites among the clothes in Adrian's closet, warning me not to borrow them. I ignore the notes, but I think it's sweet of him to guard her possessions like that. My boyfriends have all been city men, who regard their things as theirs and mine as mine. None of them has ever pinned notes to my clothes.

Men, jobs, kids. Our lives keep drawing us apart. But we don't go far, or for long. After all, that cat is waiting for me, and I haven't given up talking Ade into a baby. I called her when my son was five minutes old to tell her that I was naming him Patrick Adrian, after her. If she ever has a son, I keep reminding her, I certainly expect her to name him Margaret Adair, after me.

▼ ▼ ▼

Confessions of an Only Adult

S ometimes I'm asked how it has affected me to come from a large
family. This question isn't always posed by a boyfriend reeling
from a nightmare family dinner, but sometimes comes from a friend
who grew up without brothers and sisters and wonders what he
missed.

I don't always know what to answer to this. If I didn't have six
brothers and sisters, I'm convinced I'd be pretty much the same per-
son I am.

For example, I'm sure lots of people jump on their own couch
yelling "Dibs!" even if they're alone in their apartment. And lots,
hearing a crash out in the street, will automatically blurt out, "It
wasn't me!" It's pretty normal, I think, to hide your deli sandwich
behind the milk in the fridge so that nobody will steal it, even
though your closest siblings live 15 miles away.

Anyway, I know what I missed not being an only child, because
here I am an only adult. I know now what it's like to be alone in a
house, and I'm very comfortable with that, as long as it's as it is right
now, with three girls practicing the Running Man dance in the
kitchen, and two little boys clubbing goldfish in the living room to
feed them to the new turtle, and the TV and radio blaring and the
phone ringing. Otherwise it might seem, you know, a little quiet.

What I don't know is what it would have been like to grow up
without all the special moments I remember, like the one when
Mickey burst into the house after we'd all been reading about the
robbery at a local store and yelled, "Guess what! Mr. Lacy's store was
robbed!" To this day, no one in my family can say "Guess what?"

without someone else answering, wearily, "Mr. Lacy's store was robbed."

If I were an only child, I would've missed the sight of Connie walking apart from the rest of us on the way to school, entirely convinced that everyone would take her for a charming child walking prettily to school by herself, and not one of those rowdy Dalys that she so exactly resembled.

I wouldn't have seen Sean pluck a week-dead rat out of the electric heater after Dad had fainted dead away. Or quick-thinking Connie slap out the lighter-fluid fire on Shannon's leg.

There was the windy afternoon when Adrian rose triumphant on water skis after Dad was about to be disgusted with us all, and the morning when I called up three of Shannon's little girlfriends on the same morning and, pretending to be him (I was 13, he was 11, and our voices were identical), asked them all to go steady. (He had told everybody I was kissing a boy out by the driveway.)

Then one day everybody was grown, with his own refrigerator, bathroom and closet, and pretty soon the moments when you actually like being from a large family come closer and closer together, and then there's this payoff.

Instead of six rivals for your mother's attention, you now have six friends you can't lose, six people who knew you at 13 and pretend to take you seriously anyway. They talk to you and tell you what their lives are like.

If you're one of the younger ones, as I am, birth order is finally working in your favor.

By your 30s, you are very glad to have all of them. But you are grown-up now, mature.

Even as you feel a little thrill of joy when you think you're getting sick, because deep down you still think it means a day on the sagging green couch in the kitchen, having mother all to yourself, still you wonder what all the fuss is about.

As if it makes any difference what kind of family you come from.

Present and Accounted For

I called my mother at home several times this week, even though I knew she was at work. I was dying to see if she'd hooked up the answering machine I got her for her birthday. I kind of knew she didn't really want one. "What would I do with an answering machine?" she said. "None of you ever calls me anyway."

But I was able, with great selflessness, to overcome my mother's objections to owning this machine and get it for her anyway. I wanted to get credit for my calls, and anyway I was out of ideas. My sister Adrian was getting her a dog. It was just like Adrian – that bold gesture. I hated her. I was sure I had beat my brother Shannon, who gave her some stupid wind chimes, and pulled ahead of Robin, who copped out with cash.

We take gift-giving seriously in my family. Since we are Irish, and use words for every other purpose except to tell how we feel about one another, it falls to a barrage of toasters, bookstore certificates, "Evita" tapes and beach towels to let mother know that we are happy she is here, and are on the whole grateful for our raising – a job she finished by herself when Dad wandered away to find himself (I believe several other people were looking for him at the same time).

We're seldom working entirely in the dark. Every year we ask Mother what she wants, and every year she says "Oh, save your money, I don't need anything." Then the Xeroxed list arrives in everybody's mailbox, naming gold hoop earrings, potted flowers, trips to New York.

It's sissy to work off the list—the idea is not to get mother what she says she wants, but to find that perfect original, unexpected thing, the one that will make her look pleased and allow her a long moment of not regretting having thrown away her youth on a lot of unappreciative brats.

Last Christmas I gave her a black and white sweater from Macy's. When I spotted it from across the store, it was so much like her that I expected it to offer me a cup of instant Sanka and drive with its foot on the clutch.

But when she unwrapped that perfect sweater she only murmured, "Thank you," and quietly folded it back in the box.

Later I realized I had never once seen Mother in a knit sweater. So the message I sent was: Guess I just never paid that much attention to what you wear, Mom.

But the answering machine was a triumph, I thought. When she unwrapped it, Mother only said, "Oh, thanks, Adair. I guess I can't avoid these things any longer," but I knew she was covering up her pleasure at getting a present so in tune with her real needs. She made more of a fuss over the wind chimes, but that was just to be nice. Everybody knows Mother hates things that just take up room. She thanked Rob for the cash and promised not to pay bills with it.

The dog turned out to be one of those little dogs that have that skinny, shiny look other dogs get when they're wet. "It's perfect for you," Adrian told Mother.

Mother looked dubious. "It's shivering," she said. But she agreed to take it home, and announced that she was going to name it Kitty, so she could call it and her two cats at the same time.

A week later, I discovered that Mother had sold the answering machine to my little sister for a heavily discounted $50. She gave Kitty to the woman up the street, paid the PG&E bill with the $50 from Rob. But there on her porch, tinkling in the breeze eddying in across the mobile home tops, was the wind chime Shannon had brought her.

▼ ▼ ▼

The Green Pool
Protects the Memories

When I was little, all the families used to go swimming at a
place we called the dam. We'd park outside the gate and hike
in, barefoot or in flip-flops, wearing our towels and inner tubes over
our heads, carrying our bologna sandwiches.

The dam was actually a deep green pool at the bottom of a spill-
way below Kent Lake, with rushes around the edges.

It had been easily 25 years since I was there, though it's in Marin,
only 40 minutes north of my apartment in San Francisco. It's always
odd to me that the scenes of my childhood remain so close, when the
years between me and them stretch further every year. It's odd to think
that I can, whenever I like, go back and stand in my own childhood.

I found myself heading north across the Golden Gate Bridge to
Marin on every conceivable pretext this summer. I was coming out
of a little romantic tailspin, and something in me wanted to go
home.

The feeling got so strong that one day I decided to take my kids
all the way out to the dam, see whether it was even still there.

We drove out Sir Francis Drake Boulevard to the end of the San
Geronimo Valley, where the road dives into the cool redwoods of
Samuel Taylor Park. The valley, four little towns stretched along the
highway, looks just the way it did when I was little. Even the Forest
Knolls Lodge is still there, dark and dim, looking as if my mother
might arrive at any moment to drag my father out. Only the cars bar-
reling past on their way to the coast have changed, from Studebakers
and Ramblers to Beamers and Hondas.

▼ ▼ ▼

We left the car on the highway. You can't park outside the gate anymore–there's a sign forbidding it. As we walked in, I felt as tall as the trees, overgrown. I was 38, walking down a road I had never walked as an adult.

Patrick caught a lizard in the bushes, and I knew exactly how it would feel trapped in my palm, its dry head butting frantically against my fingers. I couldn't pick up a lizard now. I'd be scared of being bitten.

Then we turned the last bend in the road. There it was. A new, bigger spillway climbed the hill next to the one I remembered, and the pond seemed larger. The rocky beach was gone, and though it was Saturday, there wasn't a soul around. Green signs said "No Swimming."

Otherwise, it was exactly the same. It had waited for me. I never realized before how beautiful it was, green and still, enclosed by the hills around it, a pool of quietness half a mile from the busy road.

The kids didn't want to swim anyway–they said the water looked "moldy." They took off to explore. Left to myself, I sat on a rock and saw again the families spread out on the rocks, my mother chatting with the other women, rubbing Coppertone on her tanned skin and shielding her eyes to watch us swim. She looked as if she'd stay there forever, never taking her eyes off us.

On our way back to the city, I stopped at the grocery store on the highway in Lagunitas, the town I grew up in. As I stood in the doorway listening to the kids arguing somewhere behind me, I felt more at peace than I had in months.

Off to the right a wooden bridge led to our old house. Across the road was the spot where Kathy Peterson disappeared into a big puddle, Peechee folder and all, and had to be hauled up by the hood of her jacket.

It was wonderful, after all, to be a grown-up, to have the sun shining down, money in my pocket and the kids in back of me. And it was wonderful to have this, too, this green valley, waiting for me whenever I needed to go home.

THE HOLIDAYS

▾ ▾ ▾

"Everybody should wear a costume on Halloween, except those for whom it would be redundant."

▾ ▾ ▾

The Right Way to Do Halloween

It's Halloween again. In an effort to do my part to safeguard the precious traditions of this holiday, I have come up with a few simple rules for tonight.

• **Rule No. 1.** No hiding in the dark and not answering the doorbell because you forgot to buy candy (or ate it all). Go to the store. Taking off before the trick-or-treating and leaving your house dark is not allowed either. Some blocks in San Francisco on Halloween look like London after the blitz. Ever watch a 3-year-old in a ball gown and wings, tripping in high heels down a darkened block, trying to find a house with a porch light on? The kids are all done by 7 or so—you can stay home that long.

• **Two.** No grilling the little guys about what they're supposed to be before you drop in their candy. Nobody likes being cross-examined, especially when his mother has pinned leaves all over him and he has no idea why. If you don't know what he is, he's a ghost.

• **Three.** Anybody who wants to can trick or treat. One of the most stinging memories in everybody's life is the moment when some jerk of a neighbor says, "Hey, you, the big kid at the back. Aren't you a little old to be out here?" Let them trick or treat until they're 90 if they want to.

• **Four.** The first rule for parents is no giving out apples. No granola. No nuts, no raisins, no homemade cookies. Giving kids nutritious snacks on Halloween is like passing off underwear as a present at Christmas. (Not to mention that these are the treats most easily tampered with.) Also, no school supplies, and no money, unless you'd like them to become comfortable with panhandling.

(Collecting for UNICEF is different.) It's only once a year, so give them candy, already.

- **Five.** The other rule for parents is no neighborhood hopping. Year after year I've watched cars fill up and head for Pacific Heights, where the pickings are supposedly better. Halloween is a neighborhood event. Besides, how do you know in a strange neighborhood which houses have people who eat children, who gives out the best junk, who very thoughtfully offers hot brandy to the adults?

And, kids? Hoarding candy is not allowed. When I was little, there'd always be some kid, usually a girl, who'd slide out her bottom drawer in March, show us her bowl of Halloween candy, and primly reach in and take out her one piece for the day. These children grow up to give out five-grain crackers on Halloween.

The proper way to behave is to let Mom inspect your booty for tampering and give her the candy of her choice as a reward. Then jettison anything with actual food value. Trade what's left with other kids until you have exactly what you want, then eat candy for 24 hours straight, until you wonder what you ever liked about it.

This brings up a question: Can parents take away some of the candy? Absolutely. Do it as long as you can get away with it, which in my experience is up to about age 4.

Finally, everybody should wear a costume on Halloween, except those for whom it would be redundant. Even if you're a gray-haired accountant staying home to watch Nightly Business Report, wrap a dishrag around your head or do a little something to your eyebrows.

Nobody should be quite himself or herself on Halloween. This night is so much about make-believe, madness and the kindness of strangers (not to mention an orgy of cross-dressing) that it seems to embody a uniquely San Francisco spirit.

And it's most of all about breaking rules, so feel free to ignore the above and do whatever you like.

It's Thanksgiving, But I Like It

All over America, tempers are rising, resentments are brewing, the suicide rate is going up. Aunt Rose is already nipping at the sherry.

It's Thanksgiving.

I should hate this strange heavy meal in the middle of a week-day. It has everything I don't like—elaborate food preparations, no presents, a slow day spent largely indoors, a ritual whose meaning—something to do with football?—has become vague.

And there's the forced cheery togetherness, the waiting forever for the turkey to cook, and the meeting each other's relatives—oh, my lord, is that what you're going to look like in 20 years? There are the expectations that can't be met, your brother Dan sliding the whoopee cushion under poor nervous cousin Nell, the game blaring from the other room and the guests smacking their lips over food they wouldn't eat at gunpoint any other time of year, dry flavorless turkey and mushy yams.

I don't care. I want in on it all over again every year.

I like the sameness of it, the unvarying boring ritual of it, and most of all the *we-ness* of it, the turkeys sliding into ovens all over America this morning, doors banging shut, so many minutes per pound of bird, what time is everybody coming?

I want the celery with yellow cheese on it, the olives, that slippery canned cranberry sauce, my token overcooked vegetable and just the tiniest sliver more of that mince pie. I don't even need to know what a mince is, not as long as I am once again eating turkey

in late November, bathed in a ritual shared by millions and passing mashed potatoes to people I like being in the same room with.

It doesn't even matter that the table's in a different house every year or that the faces around it change. Today I'll follow the smell of turkey wafting over the fence from next door, at my ex-husband's house.

The food will be extremely good, if he's cooking. Our kids'll be there, and Marjanne from downstairs, and her mother, assorted friends, and a surprise Irish contingent from Marin.

My sister Robin, blond and manic, called me from Novato when she heard I was going to Jim's this year. "Why can't *we* come?" she exclaimed. "Jim likes us. We'll be quiet, and smoke outside, and bring things."

Her plan was to show up on his doorstep with her husband, Rick, and her two little kids, and my mother, and maybe my brother and his girlfriend, and his three kids if he can collect them from his various ex-wives.

Robin was hoping that Jim wouldn't mind, or maybe that he wouldn't notice, six or seven hungry Irish ex-in-laws creeping in and taking their places at his table as if nothing had happened.

So, reluctantly, I called him up, remembering all the Thanksgivings he spent gamely trying to stay out of range of the stereo and the smoke. "I promised I'd ask you, though of course you won't want to have my family over, it's ridiculous even to think of it," I said.

But he said yes, which floored me, and reminded me of what Jon Carroll said when I complimented him on his great marriage. "Yes," he said, "but you have a great divorce."

No divorce is a great divorce. What's true is that I always have a place at Jim's table, despite everything. And Thanksgiving, if it's about anything, is about having a place at someone's table somewhere, despite everything.

The Nouveau Cool
Christmas Letter

L ast year my first Christmas card was from the Emporium. I didn't send it one; so I imagine I'll be searching the mailbox in vain this year. I used to lay down an early strafing run of cards, forcing everyone to return fire so I'd have lots, but then a boyfriend told me it's a remnant of my working-class origins to hang cards across the mantel with kite string.

So I was very ashamed of myself and now leave the stack of pretty cards in a sort of obvious place on the desk top, so when you come in you can see at a glance how many friends I have.

The burden of being cool—never an easy one for me, what with that working-class stuff pulling me down—gets particularly heavy as Christmas approaches.

I'm supposed to deplore the decorations that appear in the stores too soon, and wince when "Winter Wonderland" issues tinnily from store loudspeakers, and sigh at the commercialism and let it be known that it's all I can do to drag myself through the holidays.

At least, this is what everybody I know does. Then, when nobody's looking, they race home and pull the curtains. When they're sure no one can see them, they nail mistletoe above the doorways, spray snowflakes all over the venetian blinds and hang tinsel from the lamps. They sing along to "I Saw Mommy Kissing Santa Claus" while sipping eggnog and watching back-to-back Bing Crosby movies.

So my notion is that cool city types would love to come out of the closet, Christmaswise, and the way to do it is to fling caution to the winds and do the uncoolest thing we can think of.

That gets us back to those Christmas cards. Most of us who get cards at all get a nice tasteful picture of a pine tree with someone's name signed at the bottom and that's all, and what's the use of that, since you can't even hang it up?

Those of you with relatives in the Midwest, though, know the pleasure of opening an envelope fat with pictures and a nice newsy Christmas letter, one letter photocopied off to everybody. Nobody in the cool Bay Area would be caught dead writing a Christmas letter, it's so plebeian, so middle of the country, so—working class.

So here's my idea. Let's *all* do it this year, write a letter, all about Spot and the kids and the new tile roof and having to cart Uncle Ned off to an institution. If everybody does it, it'll be cool.

You hate to write letters? You have nothing to say? C'mon. Having something to say is overrated. Tell them what you can smell or see as you write, the aroma of coffee brewing in the kitchen, or the faint scent of dry leaves, or the sun lighting up the back fence.

Tell them what you had for breakfast, what song is playing on the radio. Tell them what made you happy this morning, or this year.

Beginnings are hard, so it's all right to start off with something inane, like pointing out that another year has passed. Then include the usual cringing apology for the photocopy.

Audience is important: If you think of your stately Aunt Mary as you write, you will write a stately letter. Instead, think of someone who will lose his mind if you write something boring and correct. I always pretend to be writing to my friend Sinclair, who can't read such tripe. It makes her feel faint and she has to lie down.

Write as if you're drunk and can't be held responsible, or as if you're not really going to send the letter at all, to anyone, ever.

When you're done, send a copy to me, so I can show the rest of the class what a good Christmas letter is like.

I'm putting up my string now.

▼ ▼ ▼

The Super Bowl Cheat Sheet

It's the Super Bowl. Once again, the football fanatic in your life will be glued to the set, oblivious to your charms.

If you'd like to share this climactic experience with him or her but have no real interest in watching grown men fight over a ball, relax. My friends Jim, Doug, Al and Bill and I have prepared some remarks for your use this Sunday. As women have long known, if you can't throw yourself into the proceedings with enthusiasm, you can at least learn to utter convincing sounds at the right times. Here is what to say about . . .

Broncos quarterback John Elway:

"He's got a rifle for an arm, but he'll blow a bunch of them. You gotta watch for the big play."

Any statistics displayed on the scoreboard:

"That tells the whole story right there."

Any missed extra point:

"That'll come back to haunt them."

At the beginning of the game:

"This is supposed to be a walkaway for the Niners, but, hey, remember the Jets and Colts in '68."

Remarks good any time:

Any use of the word "factor," as in "With the noise factor, I doubt that Elway's shotgun will work." Or you can say, "Don't forget the dome factor."

Any use of the word "situation," as in, "With Montana, it's a passing situation."

Any muffed play:
"They'll hear about that in the locker room."

If the 49ers are accused of pass interference:
"No f--ing way!"
If Montana's pass is intercepted:
"Damn. He just put that sucker up for grabs."
If he throws to Rice and Rice catches it:
"The ball can have eyes." Or (admiringly) "Rice is always a deep threat."
If Rice drops it:
(With disgust) "He was holding the ball like a loaf of bread." Or, "Oh, that was catchable."
If either team's quarterback calls a timeout:
"He saw something he didn't like."
If any opposing runner (the ones in orange) has the ball:
Yell "Get him!" three times, with rising inflection. Jump to your feet. Knock a beer over.
When the 49ers have the ball:
(Casually) "I see the Broncos are using a modified nickel defense."

When the 49ers are winning:
"They came to *play!*"
When they're losing:
"It's not over till it's over."
"Whoever has the most points on the scoreboard wins."
"On any given day, any given team can beat any other given team." (Often shortened to "On any given day.")
Remarks to keep to yourself:
"Which team is which?"
"Doesn't it hurt when they do that?"
"Who won?"
Good end-of-the-game remarks, 49er victory:
"They gave 110 percent."

"It's a shame somebody had to lose."

Bronco victory:

"They took us out of our game plan. We couldn't execute."

"One team had to win."

▼ ▼ ▼

How to Be Irish for a Day

St. Paddy's Day is coming up this Saturday. As someone who's Irish all year (Daly on one side, Hanley on the other), and uncommonly proud of it, I think you should know what you're in for, if it's Irish for a day you're wanting to be.

So. St. Patrick's Day dawns.

Lie there a while longer, wondering what to give up for Lent this year. Cursing? Cholesterol? Catholicism?

My own parents lapsed from the church before I was born, denying me the pleasure of rejecting its teachings on my own, but I feel its hand on me, down the generations. As somebody said, even an Irish atheist wishes to God he could believe in God.

You're thinking maybe you won't go to work. You know for a fact the tragedies of the Kennedys followed from their having too much success. Besides, a lovely crisp day is beckoning.

Decide to break up with your lover. Spend three or four hours writing and rewriting the note, in which you say absolutely nothing about your feelings, but come up with some dazzling examples of word play. Yes, he said yes yes yes.

Feel better after a while, but send the note anyway because it's fine writing and you hate to waste it.

Dream about all you could do if you weren't surrounded by fools and dreamers. If you're a husband, blame your wife. If you're a wife, sigh at all you have to bear. (One Irish mother always spoke of her children as "my Denny, poor Betty, and that Kathleen.")

In the afternoon, call your mother, just because she's sure you won't.

If you are resentful of someone in your family, by no means call to talk to them about it. Brood for a couple of years, then cut them off without a word. This is known as "social excommunication" and is handy for reducing the number of relatives you have to deal with.

Toward dark, look in the fridge to see whether there's anything to eat. Lose interest, open a book of poetry instead. After generations of near starvation on a misty island where only poteen was plentiful, it's no accident there's no such thing as Irish cuisine.

Reread Yeats ("Nineteen Hundred and Nineteen"). Have yourself a fine sentimental moment, reflecting on the glories of a word-struck race that so reveres poets that to this day writers are not taxed in Ireland.

When you're as drunk on poetry as a person can be and still see to drive, go you out to one of the pubs on Geary, swallow Guinness black as a swan's heart, and spend hours wildly making assertions that you make up on the spot but would go to your grave defending. Charm everybody within earshot with your blarney and your Irish wit, you with not a mean bone in you.

If anyone accuses you of being drunk, retort with dignity that you are not drunk. You were over-served.

If you have even the slightest whiff of the bog wafting past your family tree, offer to fight anyone who casts aspersions on the Irish, including those who accuse them of being combative. Be taken aback at your own aggressiveness and consider going into the police force or politics (fully 17 presidents were sons of Ireland).

Don't be writing irate letters to columnists, accusing them of defaming the Irish. As Dr. Johnson said, "The Irish are a very truthful people. They never speak well of one another."

Happy St. Patrick's Day. May you be in heaven half an hour before the devil knows you're dead.

MEN

▾ ▾ ▾

"I've figured out why first dates don't work any better than they do. It's because they take place in restaurants. Women are weird and confused and unhappy about food, and men are weird and confused and unhappy about money, yet off they go, the minute they meet, to where you use money to buy food."

▼ ▼ ▼

First Love
and the Impossibly Cool Ian

W hen I was in the third grade, I lived in Lagunitas, out in West
Marin, and Ian lived in Forest Knolls, about a mile away. It
was 1960. Mother sang along to "Steam Heat" on the record player,
Eisenhower was president, my older sister had just got a Hula Hoop,
and I was in love with Ian Cooper.

On Valentine's Day, I gave Ian a huge red heart to which I had
glued about 50 little candy hearts. From across the classroom, I
watched him picking off a candy. When he saw me watching, he
scowled. He had given me the smallest possible valentine from his
cellophane package, one about two inches across.

I didn't care, Ian was the smartest boy in the class, shorter than
I was, with light sandy hair and an impossibly cool gaze. Once he
had spilled his milk all over the desk and cried, but I chose not to
think about that. He was the first boy I ever loved, and I loved him
unreservedly. For the first time in my life, I was glad to have been
born a girl because it meant I could grow up to marry Ian.

Ian's own feelings were clear enough—he wished I had never
been born, never wound up in his third-grade class, and, above all,
never found out where he lived.

I went to see him as often as I could. I'd ring the doorbell over
and over. "Oh, it's you," he would say, opening the screen door with
an air of resignation that meant his mother had told him to let his lit-
tle friend in.

Luckily for me, Ian had a price. "Can you come to the store
with me?" I'd ask. "I have 50 cents."

You could see the struggle on Ian's face. On the one hand, someone might see him in my company. On the other hand, 50 cents could buy a lot of Charleston Chews and Big Hunks.

"Let's see it," he'd say, and I would have to dig in my jeans pocket for the dimes and nickels I'd made picking blackberries from the bushes above the road and selling them door to door.

The time always came, too soon, when Mrs. Cooper wondered aloud whether my mother was missing me. I'd head home, then call Ian up to assure him I'd arrived safely.

When I learned we were moving away, at the end of that year, I ran to the phone to call Ian. "We're moving to Santa Cruz!" I said.

"Good," he said, and hung up the phone.

I called him back. "This is your last chance to be nice to me," I pointed out.

"Good riddance to bad rubbish," he said in his piping voice, and hung up again.

And that was it.

I never saw Ian again, except for an occasional glimpse across the crowded corridors in high school, but I never forgot him.

What I like remembering about Ian is not Ian, who I now realize was probably a somewhat priggish and uninteresting little boy. My memory of him—maybe everybody's memory of first love— is really of myself as I was then, heading down the hilly, candy-wrapper-strewn trail between our houses with my straight brown bangs high and foolish on my forehead, bearing my heart on my none-too-clean sleeve.

Remembering him means remembering an age when the cold nipping my ears was colder than it would ever be again, when the sky was so blue I stared at it endlessly, wondering where all that blue came from. When blackberries mashed in milk tasted so good I had to walk up and down in the yard as I ate them. When I loved unreservedly and asked for nothing back.

▼ ▼ ▼

Memories Are Made of This

I t's stuffed cover-to-cover with "1,500 Great Wedding Ideas," the current issue of *Bride's* magazine is, but it still overlooks one possibility—one cheaper than an expensive, nerve-wracking party and, with the proper lack of planning, more romantic.

An elopement to Reno.

First, it's a journey, and journeys are by nature meaningful. A rite of passage should involve travel, preferably on a major highway at dawn, if you really want to feel you have forsaken all others. Also, by going to Reno you avoid the single biggest mistake people make in planning their weddings, namely inviting their relatives.

I got married in Reno once. It was 20 years ago today. I was 18, hideously dressed in a glaring blue dress from Penney's with a gold frog on the lapel. At the wheel, his throat nervously working, was my beloved, Michael Lara, a tall, handsome, lift truck operator barely out of his teens. He had the world's steadiest gaze, made $300 a week, and said he would love me until the day he died.

In the back seat, wrapped in blankets, were my sister and her boyfriend, Johnny Malaspina, Michael's cousin. Johnny started to cry whenever he remembered that Mike and I were in love and getting married.

Michael held my hand so hard during the ceremony I thought he'd break it. We spent our wedding night in Colfax, which is where the car broke down coming back. Mike and I had the front seat. At one point someone's knee hit the car horn by mistake, but the bridal

party, buried under a pile of jackets, didn't stir. They were determined to remain politely asleep, no matter what.

I can't guarantee your own sprint to Reno will be this filled with unexpected adventure (or this athletic), but I bet it won't be dull.

First, rather than making the whole thing leaden with planning, just wait until the fancy seizes the two of you one fine morning, then gas up the car and go. All you'll need are some dress-up clothes, a cassette of "Chapel of Love" to blast along the way, a Polaroid camera, four or five bottles of champagne in an ice chest, and a couple of wedding bands, preferably not ones left over from your last adventure.

Bring some congenial friends along as witnesses. If you have neglected to make any friends, they will be provided for you by the chapel at a nominal charge.

Have them follow you in a separate car, so that you and your intended can ride separately, if you are superstitious about seeing each other before the ceremony (or at least before the first time you all stop for gas).

The choice of a chapel is critical. None of them err on the side of good taste, but if it isn't a red plush nightmare, you aren't trying hard enough. Try for one of the ones with lawn furniture covered in red velvet facing a crimson canopy, itself flanked by tall urns bursting with red plastic flowers. It's like being encased in a giant valentine.

For an extra fee, you can sometimes get a videotape of the ceremony tastefully intercut with bucolic footage of the Truckee River. Find a cheap motel within easy walking distance of the chapel where you all get dolled up. (The motel will be handy for later, too, of course. Beats the front seat of a car.) Later on you can go out gambling, if that doesn't seem redundant.

The ceremony takes about an hour, even with all the kissing and the picture-taking. Michael and I didn't work out, but we were kids. With the proper care, a Reno wedding can last as long as any other kind.

Even a lifetime.

▼ ▼ ▼

It Is Possible
All Men Are Not Jerks

M en are getting kicked around again. Give them enough Roper
Organization polls, sponsored by Virginia Slims cigarets, and
they could hang themselves. We women, says the poll, have much
higher standards for men than we used to, and the beasts aren't
meeting them.

I never saw a sex with a worse image problem. "Mean, manipu-
lative, oversexed, self-centered and lazy?" Bruce Bellingham said in
Herb Caen's column: "I'd like to respond to that, but the whole
thing is beneath me. Besides, I can't be bothered."

It's true, of course, that men don't fall all over themselves trying
to beat you to that sink full of dirty dishes, that they still make pots
more money, and that they say and do things that make you wonder.
My own boyfriend, Neil, makes the most astonishing remarks,
mainly relating to imaginary differences between the sexes, and then
wonders why I'm not writing them down.

Another friend, one of the most civilized people I know, one
who won't even park in people's driveways in case his car might be in
their way, winds up in bed with women he doesn't want to see again
simply because he can't think of another way to end the date.

But men are not the only ones to make neat little end runs
around fairness and understanding.

When I came to the city and got a job on a magazine, I started
running around with a group of bright, educated women, mostly
magazine editors, who seemed to have one credo to live by: Men are

jerks. We could smoothly get through almost any conversation, about almost any man, just by repeating it: "They're all jerks."

If women want to dismiss half of humanity as "jerks" they should get to. It's always a pleasure to wrap up complex affairs in a single word. Men have been dismissing women in much worse ways and for much longer—though it was always their loss.

Sometimes, though, I was bothered, listening to my women friends talk. Especially because I had a boyfriend at the time. I made some mistakes, he made some mistakes. "Jim hasn't called in three days," I confided to Pamela one evening after work as we walked to our cars. I was just telling her, the way you do a close friend when a relationship is causing you pain.

"He's a jerk" Pamela answered. This was, amazingly enough, meant to comfort me. It was a moment of female solidarity. "He's a man. What can you expect? Forget him." She patted my arm. We had reached her car, and she was fiddling with her keys.

It took me a moment to recover—I was that shocked. She was talking about somebody I cared about. Jim was many things, but he wasn't a jerk.

I couldn't help wondering if this went for all males. If I said, "My son didn't call," would she say, "Forget him. He's a jerk."?

Whatever it is, it starts young. Morgan came home distraught from school awhile back, dropping clothes and books and her back-pack on her way into the house as if she would need a trail to find her way out. She threw herself on the couch. "Why did Nathan have to break up with me, Mom? Now he's a jerk."

This was said with a trace of real regret, an emotion not often found in the cynical sixth grade.

I'm going to go way out on a limb here. Maybe all men are not necessarily jerks, even Nathan. We could even find something other than each other to batter for a while. We might start with Virginia Slims cigarets for women, a distinctly odd vehicle for carrying tales about morality.

Vacation from Hell

Ten hours on I-5. Rest stops. Good-by pees. Coffee in leaky Styrofoam cups. Tuneless singing from the back seat. Kids who would rather have stayed home with their friends.

Vacation from hell.

To say that we were all looking forward to the vacation would not be the truth. My boyfriend Nick was looking forward to it—it was his trip, his car, his maps, his tent, his friends we would be staying with, his idea in the first place. I had some hesitation, not only for that reason but because I knew I would probably kill him before the week was out—or be found floating in the river myself, tied to an improperly rolled sleeping bag.

My kids were looking forward to it as much as they could to any trip in which they would be bossed around for a solid eight days by the boyfriend they wished was dead. Nick's kid, 5-year-old Erin, had managed to catch chicken pox two days before we were to leave, but her plan for escaping the vacation was foiled when the doctor said just sponge her down once in a while.

All went well at first—that is, until we got out to the sidewalk and started loading the car. Nick strapped our bags to the top of his new Taurus station wagon while reciting his rules. No eating or drinking in the car. No coloring with markers. Seat belts at all times. My kids listened very politely, I thought, for kids not overwhelmingly familiar with the concept of rules. They think from my training that a rule is a kind of spontaneous remark that Mom makes when she gets mad—and forgets all about when she calms down.

I admit that my own mind wandered a bit during the lecture.

Nick had asked me for help with the straps, but as the help seemed to consist entirely of standing there like a dummy while he tugged on orange cords in a luggage-confining system comprehensible only to a male, I thought my time was better spent skimming the morning news to make myself a more stimulating companion on the long drive.

Finally, we were on the open road. Baggage on the roof, baggage from other relationships in our hearts, the offspring from previous alliances squashed together in the backseat, we headed south.

Deep down, we knew this was folly: even Romeo and Juliet would have bickered in a station wagon on I-5, Romeo wondering if all the Capulets whistled as tunelessly as that and Juliet kicking herself for not letting Dad convert that balcony into a breakfast nook after all.

In fact, Romeo and Juliet had no problems compared to us. They had no kids, and for all they knew were both fetishly neat around the house. There was some difficulty with the relations, I admit, but I'll put an ex-spouse up against a murderous father-in-law any day. Your father-in-law doesn't call up every five minutes wanting the rug back or telling you that the children of divorce are basket cases by their 21st year.

Nick and Erin live right next door. His wife left him a year ago, taking half the furniture but overlooking the many pictures of herself. Nick has Erin half the week, which they spend going to the park and eating nutritious, balanced meals and really communicating. Her toys are arranged on the shelves as if by a museum curator. I find it so scary that I've been afraid to ask which one of them is responsible.

Meanwhile, next door in an identical flat, the kids and I are couch-potatoing it, slurping down instant cup-a-noodle soup and Lifesaver Popsicles in front of our well-worn tape of "Grease 1." At my house, it takes two people to put the toys away—one to toss them into the toy closet and the other to shut the door fast before everything falls back out.

We fell in love before we knew any of this. I looked into Nick's long-lashed dark eyes that first night when he came to a party at my

house and never dreamed that this temperature-raising hunk in black jeans was also a DAD, with tedious views on the subject of television viewing and applying rules consistently.

Two hours out on I-5, as we were floating in the jet stream of a caravan of trucks, my son Patrick got thirsty. He has always been a very thirsty kid. And for the first time in his life, I could do nothing about it.

"Sorry, next rest stop isn't for 45 minutes," Nick said, not looking sorry at all. Then he looked at me, as if tempted to ask me to take my feet off the dashboard.

I stared out at the hills and at the candy wrappers blown against the chain-link fences and wondered why I was thinking of blending families with a man willing to let a 7-year-old of mine expire in the back of a station wagon for lack of water.

We reached San Diego at 10 o'clock at night, after stopping for dinner at one of the family places by the roadside. My kids had to be pulled from under the table three times, blew the paper off their straws, drew pictures in the spilled milk at their places and peppered the waitress with questions about her hairdo. I didn't blame them, after such a long time in the car, but Nick got very quiet. Erin was an angel, of course, and I very innocently asked Nick if she was feeling all right.

Once in San Diego, we had a succession of days that were kid heaven, grown-up hell. The beach, the zoo, Sea World. By the time we were on Nick's friends' sailboat, heading for Santa Catalina Island, I knew I didn't want my spontaneous, lively offspring exposed to a brand of parenting so repressive that children were punished after only one or two warnings and rules persisted even after the actual offense was over. And from the alarm on Nick's face every time my 9-year-old dropped a little ice cream on the scrubbed deck of his friend's sloop, I could see this trip had not banished his every qualm about making us one big happy blended family.

"Blended families" is a fantasy term. They used to call them "stepfamilies" until Cinderella and her kin robbed that word of its tender connotations. Then they tried "reconstituted," but that

sounded too much like families that had been reduced to powdered form. They're still far from finding a word that makes it sound like fun.

Our own attempt at blending was going like lemon and milk.

As we headed back up the interstate that Sunday, the exhausted kids nodding off in the back, we both pretended great interest in the billboards rushing past. Then, at the rest stop up on the Grapevine, Nick sent the kids off for their good-by pees (I had convinced him I didn't need one) and came to me looking flustered, his eyes lowered. He said: "One of your kids' sleeping bags fell off somewhere on the road. I'm really sorry."

With his eyes lowered like that, I couldn't help noticing all over again what nice long lashes he has.

We're still living next door to each other, still in love and still reveling in the luxury of not having to live together. What with separate houses, heading in opposite directions on family Sundays, and most definitely with separate vacations, we think we have a pretty good chance at happiness together.

▼ ▼ ▼

How to Bring Mom
Back Down to Earth

When I started going with the man I'll call Nick, the kids told me they not only didn't like him, they didn't even like his hair.

"His *hair?*" I said. "What's wrong with his hair?"

"Or his voice," they replied, glowering over their Rice Krispies. "We hate his voice."

Morgan, then 9, told me about the dream she'd had the night before: While driving over to pick up her and Patrick, Nick and I are killed in a traffic accident. I miraculously come back to life, while Nick, conveniently enough, stays dead.

When I admitted that Nick and I had talked about living together, Patrick, then 7, started kicking the bed with his feet.

"Where will Nick sleep?" he asked.

"In my bed."

"Then where will *you* sleep?"

Every mom wants to think of herself as Supermom, that her love for her children will protect them from all harm, even as she juggles them and work and hobbies and men. I have read the literature on toxic parenting—I know that a single misstep could land these vulnerable beings on a couch years from now.

"Yes," they'll tell their shrinks, "Mom did buy us Guess? overalls, sat on the floor making paper chains for the Christmas tree and tried to learn to moonwalk, but she also had these *boyfriends.*"

Bringing home boyfriends is not a supermomish thing to do, not for kids who have a dad and aren't looking for another one.

So I would try, in the best Supermom tradition, to get them to

136

share their feelings with me. "I know it seems as if Nick's over a lot," I once began, uncertainly, and Patrick blurted, "It seems that way because it *is* that way."

At night the two of them would creep into my bed and curl up, one on either side of me, like sentries, keeping Dad's place safe from intruders.

The kids didn't like the sharing part much, perhaps suspecting that the idea was to get them to accept what they had no intention of accepting. Morgan's friend Holly sympathized with her, saying, "Yeah, my mom's boyfriend comes over practically every night, and we have to have all these pathetic talks."

Things never got much better with Nick. I tried, idiotically, to *make* the kids like him, the way I made them eat their broccoli. I even found myself, one morning over the dishes, arguing with Morgan about whether he was good-looking.

Then I started not liking his hair. One day Patrick flatly refused to stay with Nick while I went out, and I looked at him, surprised. "Do you mean you still don't like him?"

Patrick looked up from the space shuttle he was building out of Legos. "Welcome to Earth, Mom," he said wryly.

Welcome to Earth, Mom.

It's not easy, being a mom here on Earth.

Or being kids.

Or being the new, threatening stranger in the lives of those kids.

When Neil came along, he and the kids took it slow, getting used to each other. "I like Neil," Patrick told me, although just saying it made him feel disloyal to his dad. "I just wish you didn't like him so much."

Neil spends hours wrestling with the kids and helping them with their homework. He even smacks his lips over their cooking, which last time was cookie salad, grapes with eyeballs painted on them and meat loaf surprise.

My plan this time, which is to just leave it up to the three of them, seems to be working.

If it doesn't, I know the kids will be the first to welcome me back to Earth.

In the Art of Nagging,
Timing Is Everything

I dribbled the batter into the frying pan and watched it spread into a perfect circle. I was making pancakes for the kids, and when Neil wandered sleepily into the kitchen, I offered to make him some.

"Sure, great," he said. Then he peered into the pan and frowned. "Kind of thick, aren't they?"

"Some pancakes are thin, some pancakes are not so thin," I answered, serenely. It was my house.

"Did you know when they get bubbles like that it's time to flip them?"

Did he know when men ask questions like that it's time to kill them?

Neil and I have been spending more time together lately, and it looms in the future like a dark cloud—Living Together. You can tell it does, although we haven't spoken of it, because our domestic behavior is now tinged with panic.

In the morning, Neil stumbles into the bathroom after me and stares like a doomed man into the sink. "Can I live with a woman who leaves toothpaste in the sink?" he asks himself. "Do I mention it, and rend the perfect harmonious fabric of our love, or stifle my rage anew every morning for the rest of my life?"

It's a good question. When my husband and I had been living together a month, he said, hesitantly, "Do you think you could dry off in the shower, instead of dripping on the hardwood floor? It's been leaving a puddle."

I got to enjoy the thought of his waiting outside the bathroom

138

30 mornings in a row, waiting for me to finish my dripping so he could go in and mop up his buckling floor.

So the rule about nagging is, if you think, say it–and do it early.

Lovers don't want to do this. They want you to guess. They want to brood, thinking, if she loved me she wouldn't store cosmetics on the grocery shelf. If he loved me, he wouldn't wear colored T-shirts in the first place.

When I was little, I told my mother my hands were cold and she said, absently, "Don't complain." This puzzled me. How would she know my hands were cold if I didn't tell her? Nagging is like complaining–necessary information that can make you feel like a wimp for bringing it up.

Still, I'd rather Neil mention the toothpaste now, trying for a light tone, than take a sledgehammer to my sink a year from now.

Just as I can choose now to ask him to help with the dishes more, or wait until I am standing over his still form on the linoleum, blowing the smoke from my gun and saying, "Never mind, sweetie, I'll get them this time."

The second rule is, there is more than one way to deliver the message.

I learned this from Neil. The other day I made him toasted ham and cheese on a bagel for dinner, and he said, "This is terrific, thank you."

"Don't mock me," I growled. "I know I'm not much of a cook."

"No, I mean it," he said, kissing me. "This means a lot to me."

That was when I realized Neil has been kissing me a lot lately. Whenever I wander into the kitchen, in fact, which at first I did only to turn up the music. When he saw I was coming into the kitchen more and more, he started nuzzling my neck whenever I got near the stove. If I drifted away, the caresses stopped. Pretty soon I was thinking: cooking, love. Love, cooking.

I am toying with the idea of trying this myself next time Neil and I go out to dinner. Drag him under the table and reward him until he gets the message: love, dining out. Dining out, love.

Eight Perfect Mates
—the Mind Reels

I was lying on the couch in my apartment the other night, flipping through a magazine in search of Calvin Klein ads, when I read something that made me sit up with a start. It said that everyone alive has eight perfect mates somewhere out there, wandering the world.

I let my eyes rest on that line again. I don't believe everything I read, but this had the ring of truth—that is, I needed for it to be true.

The only other occupant of my apartment at that moment was a pet rat who had been staring at me through his glass cage. It was a chilly evening, and he needed something to snuggle up to.

I had just the thing—Neil had left his favorite Hawaiian shirt here when he left on his weekend without me. Torn into strips, it would make a perfect blanket for the rat.

The one in the cage, I mean.

I turned my attention back to the article. I was in heaven. Eight. *Perfect?* According to Random House, "perfect" means "without any of the flaws or shortcomings that might be present." The mind reels. Eight Ken dolls, correct in every detail.

I glanced across the room at Neil's picture. He was looking at me from his frame with his eyebrows raised, wondering what I was up to this time. But Neil isn't perfect. Failing to appreciate me properly, for example, is certainly a flaw.

I turned back to the article, treasuring its implications. For each of these men, I am the feminine ideal. For them heaven would be a

lazy Sunday afternoon at my place, with "Graceland" blasting on the stereo, Morgan dribbling her basketball in the living room, and the dishes piled high in the sink while I, their dream woman, snored prettily on the couch with the *TV Guide* over my face.

I was immensely cheered by this thought until I remembered. There are seven billion people in the world. Where were my eight? Was one wading through rice paddies in Mongolia, another kicking dogs out of his path on a back street in Madrid?

Were they pining for me, doomed never to know that I am waiting here in a Western city by the sea, thousands of miles from the rice paddy and the sunstroked alleys of Spain?

Then I recalled the word "perfect." How could a guy be perfect for me if he's soaking his well-formed calves in a Mongolian rice paddy and I'm lining a rat cage in San Francisco? Surely being 10,000 miles away would count as a shortcoming? I decided perfection must include proximity—if these eight guys are perfect, then they, too, wouldn't live anywhere but San Francisco.

They're here, and they're looking for me, the perfect woman for them. But how will I find them? Surely the gods wouldn't put eight ideal men in the same city with me and then wait, giggling and slapping one another, as I try to find them among 700,000 people?

Then another, even more chilling thought occurred to me. If each of those guys has seven other perfect mates, that means I have 56 rivals out there—each of them flawless. And only eight of them have to get there ahead of me for me to be left out in the cold.

No wonder I have always found math depressing.

Should I tell Neil he has eight perfect mates here, too? Eight women who, finding he has gone off on a press junket and didn't invite them, would only smile forgivingly at him?

No. Wait until he asks.

I had one more thought. If each of my mates has eight mates, and each of those has eight, and so on, that can mean only one thing: all the perfect people are here, in San Francisco.

Do You Know
Where Your Plants Are?

I t's 11 o'clock at night, and I'm alone in my apartment. I just
watched "The Untouchables," feeling guilty about it because the
kitchen table overflows with paperwork and the sink with dishes.
My life overflows with people, too, so it's amazing how I feel it, the
absence of just one person.

I'm remembering what my daughter, Morgan, said to me the
other day: "Even though my life is a mess, I know exactly where
everything is."

Right. It's like that comic who said, "I didn't lose my job. I
know right where it is. It's just that another guy is doing it now."

I didn't lose Neil. I know right where he is.

Not that I'm dwelling on it. On top of the pile on the table is
the *New York Times*. Folded into it is the usual notice threatening
anyone who steals it with six months' imprisonment. I can never
read this notice without picturing a circle of hard-bitten cons in
prison blues swapping exploits in the yard. When the conversation
turns to what they're in for, one says murder one, another says armed
bank robbery, and the third mutters, "Got caught with a copy of the
Times."

Sorry, my mind is kind of skipping around tonight. Looking for
distraction, I open the paper. First to catch my eye is a story about
a study in which 12 pairs of identical twins are shut up in a dormi-
tory for three months and forced to gain weight.

Each pair gains identically, showing conclusively that, first, weight
gain is hereditary, so it makes as much sense to blame people for being

fat as for being tall or blue-eyed; and, second, that people will do the weirdest things to themselves when scientists tell them to.

Still not sleepy, I pass on to the Living section, where I can usually count on finding some gossipy trivia among all the news this lofty institution considers fit to print.

Oh, *perfect*. It's an article about shrub rustlers in New York. Bad guys have been stealing valuable plants, leading to what the writer, fighting down a giggle, calls "the new science of floral bondage." Gardeners all over Manhattan are chaining up their Scotch broom, their azaleas, rose bushes and their dwarf maples, which is a good New York response. Here they'd be forming support groups.

I almost pick up the phone to call Neil to tell him about this, but I stop myself. He gets the *Times*. Let him read it himself. I scowl at his picture, just for good measure. He hasn't been calling much lately, and I have, with equal dignity, been refusing to take the calls he hasn't been making. It's a draw.

I read on. The thieves give themselves away with wheelbarrow marks. There have been police stakeouts in Central Park's Conservatory Garden. For all we know, the beleaguered gardeners have arranged for undercover plants among the community garden staffs.

One has a method for protecting plants that he refuses to divulge: "Let's just say I advise people on the need to restrain their plants."

I can't sit in my kitchen reading stuff this funny by myself. I consider calling my sister in Ukiah and waking her up. I'm tempted to read it to the newts.

But what I want, what I really want, is to call Neil and just read him a little bit of it, maybe just the part where the writer loses his battle with the giggles and says, "It is tempting, when confronted with a rhododendron in chains, to conclude that something has gone wrong in New Yorkers' relationship with nature."

You miss somebody most during these moments, when you read something funny, turn automatically to share it – then, even as you stretch out your hand for the phone, remember.

Money Plus Food
Equals Disillusionment

'**I**'ve figured out why first dates don't work any better than they do. It's because they take place in restaurants. Women are weird and confused and unhappy about food, and men are weird and confused and unhappy about money, yet off they go, the minute they meet, to where you use money to buy food.

Say, for example, that a man and a woman meet "cute," as the expression goes. They've been bumped from the same flight, and are fuming separately in the airport bar, waiting for the next one, when they spot each other. He is craggy and dark, in that way she likes. He's wearing designer jeans but she instantly forgives him.

She is blond and lithe, with the kind of intelligence that looks intelligent even in photographs, even in repose. She is paging through a self-help book, but he forgives her.

They fall into conversation, and he says he has a car, why don't they go into town for lunch?

At the back of their heads, the old song starts up: "Oh, I *like* this one. Could this be the one?"

Then it starts. He parks three blocks away from the restaurant because parking in lots makes him feel like a sucker. He is hunter. He will find parking space in jungle.

She doesn't know he is hunter. She thinks he is cheap.

She wonders, now, if he's going to turn out to be one of those guys who gloats over the deal he got on his Reeboks and never buys himself any new clothes.

She now has reservations, although the restaurant doesn't require them.

They enter the dining room and are shown to a quiet table at the back. They talk. They discover they both like stud poker, hated "Raising Arizona," like to walk down city streets in the rain. When they get mixed up over whose water glass is whose, their hands touch.

The waiter appears, and the man orders a hamburger, medium rare, with home fries.

The woman considers the menu. "I'll have the Greek salad," she says, "with the dressing on the side."

As he watches with horror and fascination, she tears a roll into little bits and then eats the bits. He wonders if she's one of those women who knows what all her clothing weighs. He bets she can list everything she ate yesterday.

She notices his look, and guiltily stops rolling the last bit. "I had a late breakfast," she lies. She is on a diet. She's been on it since she was 12.

When the bill comes, he is unsure whether he should pay or not, and lets her pay half. But, she is thinking, lunch was his idea. Also, he has pocketed the receipt. He's going to write this off. A flicker of annoyance crosses her face. She really hates his jeans now.

Both of them move their chairs slightly away from the table, hugging their disappointment to their breasts, neither of them aware how contrary they're being.

She wanted him so stupefied with passion at the prospect of lunch with her that he absentmindedly abandons his car to the nearest lot and can't remember his own name, let alone the receipt. Yet she likes it that he has money, and after lunch she wants him instantly to resume his thrifty ways, so they can get a nice split-level.

He wanted her to abandon her habitual pickiness and order the biggest, juiciest hamburger on the menu, because a meal with him should be a celebration. But he likes it that she is slender, and would be happy if, right after lunch, she were to resume her lifetime diet, so he can enjoy tracing the line of her adorable jaw.

Shortage of Women:
Ain't It Awful?

I t's been all over the news: There are now way over 2 million more men in their 20s than women the same age, and the imbalance is only going to get worse.

Demographer Jib Fowles told *The Atlantic*, "Women are becoming more valuable, simply because of their scarcity. Nobody likes to think of the marriage market this way, but the raw numbers are powerful. It's going to be an interesting period."

As a fellow scarce and valuable being, I must apologize for that tiny hint of jubilation in Jib's tone.

I hope I don't sound as unsympathetic as she does. I think it's a shame there are going to be so many more men than women.

Honest.

This is not how it was supposed to work out for you guys. There are 106 boys born for every 100 girls. As both the weaker and the more combative sex, you were meant to drop like flies all along the way, in wars, barroom brawls, duels and so forth. This had its inconveniences, but it did assure the survivors a plentiful supply of women. Even a total geek in high school pretty much has his pick of the nursing home by the time he's 75.

Now, with the onset of world peace and the advances of medical science, you guys are not doing one another the favor of dropping dead. You are living longer, and there are an awful lot of you.

I suspect we won't be needing anymore those state-by-state guides called "Where the Men Are," the ones that advise us to move

to Alaska or study mining engineering or hang out in noisy sports bars, batting our eyelashes.

We know where the men are now. You're everywhere. *Life* is a sports bar.

Now you have discovered that it's all a game of musical chairs, with every marriage removing one man and one woman from the game. If you don't want to be left standing when all the chairs are taken, you're going to have to jump fast.

Trouble is, you fell into some bad habits back when you were in demand. You are a little out of shape, a little complacent. You are not—let me use a sports metaphor so I know we're communicating—at the top of your game.

"Oh, well," you sputter, "but the population bulge is for dorks in their 20s, gangling pipsqueaks who think a power tie is something you do to your tennies. My woman would never go for a younger man."

No, hon, of course she wouldn't. There's absolutely no truth to the rumor that women, now getting power from within, have the self-assurance to do the Cher thing, and fish at the shallow end of the dating pool.

We have no interest in men with size 30 waists who actually *ask* to go out dancing. I would also discount that woman quoted in this very paper, a Beth Martello, 35, who said, "Younger men have more enthusiasm, they're more open to new ideas. I've dated a 26-year-old myself."

Why should you have to worry about your woman running off with a younger man? You gave her the best years of your life, right? Besides, you have earned that gray at your temple, that slight soft-ness at the belt line, that preference for staying home to watch "thirtysomething."

Still, I guess you are going to need a way to stand out in the crowd, aren't you? It may mean time spent poring over the news rack, studying the articles that will soon be coming out: "How to Look Good for a Woman," "Women Who Can't Commit," "Where the Women Are," "How to Compete With a Younger Man."

It's going to be an interesting period, indeed.

But—Does Bill Know?

S o the main squeeze and I went house hunting on Saturday . . .
*Editor: Wait! What do you mean, you're house hunting with the
main squeeze? Who is this guy? Did I miss something while I was out of
town? You can't just hit people with this out of the blue.*

OK, quick update on That Bill, as he tells me he is now known
("Oh, you're *that* Bill"). We met in the elevator at work three
months ago. I noticed this guy out of the corner of my eye—tall, easy
on the eyes—leafing through a stack of newspapers. He got on the
elevator and said his happiness depended on knowing my name.

OK, OK, I asked him whether he worked in the building. I
wasn't flirting. It was just important to me to know, just at that
moment, who worked in the building and who didn't.

I administered the standard test—took him to a waterfront dive
and ordered the house red. He didn't flinch. Furthermore, he has
assured me I am the first woman he has ever been with—he and his
first wife were just friends.

Moved by the frankness of this disclosure, and keeping in mind
it was made by a fellow Irishman, I have let him in on a secret about
my two roommates, the short ones who pay no rent and fling bits of
rolled-up clay out of slingshots at the kitchen windows. "They call
me Mom," I told him, "out of affection and old habit. Actually,
we're just friends."

Fade to: calendar with pages ripping off. Thanksgiving goes by,
the holidays, the New Year. We meet each other's families.

My mother thinks Bill's funny—and she's the one who usually

starts liking my boyfriends about two years after we've broken up ("Where's Ted?" she'll ask about the man she encouraged to wait out in the car. "I always liked him"). My sisters make it a point of liking my boyfriends, even the ones they can't stand, but they seemed to like this one especially. His parents are so great it's as if they were sent over by Central Casting.

After that it kind of snowballed on us. Two weeks ago, Bill expertly lit a Presto log in his fireplace ("Most people," he explained with obvious pride, "would light it at just one end. Big mistake"), poured a spunky Napa red into two glasses, and asked me whether I would—I can still hardly get my fingers to type the words—*marry* him.

It took me an hour to stammer out an answer, but I said I would. Gladly.

I told the kids one by one. Patrick said, "I like Bill a lot. I guess it would be all right."

Then he bounced the basketball for a minute and said, "Does Bill know?"

Morgan was next. At first she didn't believe me and Patrick—she had to call Bill up. Then she said, "This is so great. Can I invite my friends to the party? Can I drink champagne? What are you going to *wear*?"

I said I didn't know. Before we can set a date and plan the bash, we have to figure out where we're all going to hang our toothbrushes.

So that's how we came to find ourselves, a couple of innocents wandering hand in hand, followed by two skeptical preadolescents wearing Walkmans, through the dark, murky Slough of Despond that is the Bay Area housing market.

On Thursday: A hardworking professional couple, both 39, with two incomes (but no down payment to speak of), amuse the real estate agents and the relatives as they try to find a $300,000 house with three bedrooms and two bathrooms without moving to Manteca.

THE NEWS

▾ ▾ ▾

"I rarely notice
what's going on, and when I do it's
too late."

Making the World
Safe for Muggers

It's in the news all the time now. More and more, bad guys are getting hurt on the job. A burglar in Southern California fell through a roof of the house he was trying to get into. Two men trying to steal copper cable from a naval base in San Diego were shocked to find the 12,000-volt power lines weren't dead after all.

And in San Francisco, a man engaged in a routine mugging was interrupted by two passing cabdrivers, one of them Chuck Hollom, who used his cab to pin the mugger against a wall.

Clearly, we have failed to provide safe working conditions for the criminal element. This is terrible. The risks they take make them ineligible for low insurance rates and put them at increased risk for high blood pressure. It may put a strain on their marriages, for all we know.

That's the bad news. The good news for bad guys is that, like other Americans, they are appealing to the courts in greater and greater numbers. They think the "criminal justice system" is their tax dollars at work.

The guys trying to steal copper cable are said to be suing the government for endangering them like that. The man who left his roof lying around where an innocent trespasser could fall through it was promptly sued by his burglar. Even the family of the man who shot up the McDonald's sued, claiming that additives in the fast-food chain's hamburgers brought on the violent outburst that left 21 dead.

In San Francisco, James McClure, the mugger who beat and robbed a young Japanese tourist, is not just languishing in the slam-

mer, using his 10-year sentence to contemplate the error of his ways. He's got himself a mouthpiece, and he's suing the cab company, Luxor, and the driver, Hollom, for using excessive force in making a citizen's arrest. He wants $5 million.

I talked to Hollom, who is frankly scared, though Luxor is defending him. "My net worth is about $2,500, like that of most cabdrivers. They tell me a case like this is not dischargeable through bankruptcy."

Obviously, Chuck should've thought of that before he so blindly went to the rescue of a woman being attacked.

It was a year ago May, about 11 p.m. The tourist, 24-year-old Chihiro Saka, was out with a couple of female friends at Polk and Market. That's a fairly well-lighted, populated area, which I imagine is why Saka was there and not in another part of town.

It's not that she thinks baddies can't see in bright light. It's because in the back of all our minds, those of us who live in the city, is this hope: Other people, seeing that we're being kicked and our purses stolen from us, will come to our aid. Someone will care, someone will come.

In Saka's case, someone did. Hollom, 49, a former Hollywood stunt driver, saw what was happening and spun his cab around, following the driver of a Desoto cab, Jamal Nijen, who was already chasing McClure up Hayes Street.

It was nothing new for Hollom, who's chased dozens of suspects in his 23 years of San Francisco cab driving. This time, though, when McClure seemed likely to get away, and wouldn't stop when Nijen told him to, Hollom pulled his cab onto the sidewalk, and, using his stunt driver skills to calculate the distance, trapped McClure, breaking his leg in the process.

If Hollom gets away with this I-am-my-brother's-keeper stunt, you can imagine the consequences: Pretty soon all kinds of people will assume they have a right, as citizens and bystanders, to interfere with a crime in progress. The next thing you know, it won't be safe for criminals even on the open streets.

Sure, It's a Good Idea, But...

T hey're talking about legalizing drugs again.

The current *Atlantic* has a piece on it by a guy named Richard J. Dennis.

Dennis thinks that our current holy war on drugs is futile and irrational, and that we should, in his words, "Legalize the stuff. Tax it and regulate its distribution, as liquor is now taxed and regulated. Educate those who will listen. Help those who need help."

Legalizing the sale of drugs to adults (while keeping crack illegal), Dennis argues, would shatter the drug cartels, end drug terrorism in our inner cities, reduce crime and corruption, and save billions of dollars a year, some of which could be spent on education and treatment.

You can feel Dennis' frustration underneath his carefully marshaled figures. He's whistling in the wind, and he knows it. This country's not going to legalize drugs.

It's not going to happen.

No amount of bitter experience, beginning with Prohibition, is going to convince us that we can't save people from themselves.

Still we try. We hate to see people hurting themselves with drugs, so we try to take the drugs away.

This is admirable of us, but it doesn't work. We discover that the people we're trying to help will do anything to get the drugs, including hurting bystanders. We discover bad guys will do anything to provide them with the drugs, including hurting bystanders. We even discover that our expensive, all-out efforts to take the drugs

154

away hurt bystanders—all those other programs to fight poverty, ignorance and disease—that could use the money. We . . .

I'm sorry. It's hard to get on this issue and not rant, which is why I usually stay away from it.

I should be trying for a light touch here. But it kind of knots up in my chest. Issues like these bring up old frustrations for me, that long-ago despair I felt when I first learned, in some forgotten childhood incident, that people behave very oddly when they think there's a moral principle involved.

It reminds me of an old cartoon. I can't remember the exact wording, but a guy is saying to another guy something like, "Sure, it's a good idea, but we don't do anything willy-nilly around here just because it happens to be a good idea."

Because he knows it ain't gonna wash, Dennis devotes most of the article to a section called "Some Objections Considered."

One by one he mows down these objections. He shows that we may wind up with more addicts, or we may not—Holland didn't when it decriminalized drugs. We will for sure wind up with less crime. He says—but you can read it for yourself.

I'm going to calm down now. It doesn't help to get excited, and anyway, now that I read a little further, I see that it's not my problem anyway.

Dennis says, "Drug illegality has the same effect as a regressive tax: its chief aim is to save relatively wealthy potential users of drugs like marijuana and cocaine from self-destruction, at tremendous cost to the residents of inner cities.

"For this reason alone, people interested in policies that help America's poor should embrace drug legalization. It would dethrone drug dealers in the ghettos and release inner-city residents from their status as hostages."

Hey, *I* don't live in an inner city. I don't gotta worry my little head about this. Forget I brought it up. Really.

Forget it.

Fond Memories
of High School P.E.

I t was in the paper awhile ago: In Massachusetts they've decided
that high school students can read a pamphlet every two weeks
instead of taking gym.

If this idea catches on, it could mean the end of high school
P.E. all across America.

I read the article twice. I was appalled. It just isn't fair for our
kids to get out of–I mean be denied the experience of–taking gym.

To be properly prepared for life, goes the thinking of most P.E.
instructors, a teenager must suffer humiliation, embarrassment and
self-loathing for a prescribed number of minutes a day. When your
body is changing, erupting and leaking in alarming new ways, it is
character-building to expose that body to your scornful peers at least
once during the school day.

It is character-building, actually, just to expose your underwear
to them, especially if you wear a sweat-trapping harness or employ a
safety pin to hold up the strap of your bra.

Some would argue that the typical teenage day already bursts
with opportunities to fail in front of classmates, from being called on
in class to having to dance at the prom, but these humiliations are
too fragile, too disorganized. Only P.E. class truly mirrors life, in that
everything has been arranged for the maximum in embarrassment
and the minimum of efficiency.

At my school, we had 20 minutes to change into smelly, horri-
ble gym clothes that got taken home to be washed about twice a
semester, 20 minutes to skip the shower and get dressed again, and

10 minutes to get to the next class. This left 10 minutes a day to reap the benefit of instruction in various life sports, such as field hockey and modern dance.

Modern dance was where, at the most awkward and vulnerable stage of your life, you got out in front of everybody and executed a dance you had made up yourself.

It caused a salutary amount of distress, but for the crushing of individual spirit, nothing works better than a hundred smaller embarrassments spread over time.

Students with puny arms should have to hang dispiritedly from a bar, trying to do just one chin-up without scraping their faces off. The very modest, while doing girl's push-ups, should have to touch their chests to the teacher's hand, set flat on the floor, as she counts.

The chubby should have to shout out the size bathing suit they wanted through a small window; the shy girl should have the bathing suit stretch out in the water, so the top falls down as she's being graded on the back float.

At my school, some ungrateful students, insensible to the benefits of P.E., tried to get out of it. Girls made medical history with the number of periods they managed to have in a single year. Some simply flunked, while others showed up but pushed instructors—white shorts, whistles, clipboards and all—into the pool and got themselves expelled.

These are the ones who found themselves unprepared for life's later challenges, from the gyn exam to the tax audit to being given work they didn't particularly feel like doing.

But others toughed it out, a few because they realized that tomorrow's leaders would need to know how to make floats out of their clothes and execute a flawless jumping jack.

Others, myself included, persevered because they knew that someday, somewhere, they'd have kids themselves and would be able to force the little sissies to take high school P.E.

Read a *pamphlet*? Over our shivering white bodies.

▾ ▾ ▾

Just Say No to Broccoli

"**P**resident Bush has banned broccoli from a diet known to include pork rinds doused in hot sauce and candy bars crumbled over cereal," sniffed the Associated Press in a dispatch this week. The word has gone out: No broccoli is to be served aboard Air Force One.

For the first time since Carter insisted on doing his own reading, I'm impressed with an American president. Bush's stalwart stand reminded me of a cartoon long ago in *The New Yorker*, in which a small girl is sitting with her arms folded at the end of a long table. Her mother says, "Eat your broccoli, dear," and the little girl says, "I say it's spinach, and I say the hell with it."

It's a bleak age we live in and getting bleaker, as the dour headshakings of shrinks and scientists strip our pleasures from us one by one.

Saying no to broccoli is a mild revolt against doing what is good for us, but it might be just what we need. I see this presidential last stand as the beginning of a revolution in which we all fold our arms and say, "I say it's oat bran, and I say to hell with it."

It's time to start going overboard again—fall in love, drink too much, join the mad dogs and Englishmen who still go out in the noonday sun, and stop eating as if food were an adversary.

Instead of administering food like medicine, patrolling the supermarket aisles for gastro-demons, and eating so much roughage that you have to plan your whole day around it, take a diet tip from my friend Sam, who says, "Forget breakfast. Breakfast is *boring*. And

158

forget lunch. *Boring*. Just have a blowout dinner. If you're going to have a baked potato, have it with a cube of butter and a quart of sour cream."

And go out in the sun. It may not be good for you, but neither is cowering indoors, reading depressing tracts on the ozone, and dressing like a snowman to fetch the mail. Weigh the present pleasure of lying on the lawn with a trashy book, the sun's rays pinning you like Gulliver until everything in you goes wonderfully limp, against the wan and distant good of preventive skin care.

And love, for gosh sakes. We're dressing like snowmen against that, too. Love is a drug. If your socks creep into your shoes when his lips graze your ear—you're not in love, you're addicted to excitement. If you feel sad at hearing the door close behind him, it's withdrawal. And if he mentions in passing that he slept with your co-worker, and you experience a normal desire to rip his throat out—hell, both their throats—you're not jealous, you're "protecting the supply." Othello was protecting the supply, a trifle overzealously.

If Shakespeare were writing Romeo and Juliet today, the couple would spend the first three acts earnestly discussing their relationship before each rushed off to the shrink to find out why they were always falling for unattainable objects.

We would learn that both sets of parents were busy, distant and probably drank. Juliet would marry that twit Paris, and Romeo would blurt out the details of their romance in the pages of *Spy* magazine.

Bush knows something. Planes have been known to fall out of the sky, and he doesn't want the last taste in his mouth to be broccoli. (Why he might want it to be pork rinds doused in hot sauce is his own affair.)

We can all take a stand. Crumble candy bars over your five-grain cereal, lift your pale winter face to the welcoming sun. Step over the body of your safe and sensible lover to run off with that good-looking cad you can't keep your hands off.

We are all, as Yeats said, fastened to a dying animal. A pleasure deferred is a pleasure lost, and life may be too short for broccoli.

▼ ▼ ▼

Another Nasty Habit
Dragged to Light

Kitty Dukakis has written a book called "Now You Know" about her terrible odyssey through drugs and alcohol. She has been to treatment centers all over the country, in between drinking everything from rubbing alcohol to nail polish remover to hair spray.

The *New York Times* reviewer, Maureen Dowd, while saying the book had "the same horrible fascination as a Geraldo Rivera show," seems to be annoyed with Dukakis for not being more ashamed of herself.

Dowd devotes a long fourth paragraph of the review not to the book, but to the unfortunate trend it's a part of:

"In this era of temperance, the sins and nasty habits of old are now labeled diseases: Everything from shopping to a negative attitude to infidelity to overexercising is called a psychological compulsion beyond the control of its victims. The idea of taking the moral blame and responsibility for failings has become passe. . . . Support groups and self-help books have become a thriving business."

You can see why Dowd is worried. The idea, I guess, is that we're all tempted to drink hair spray, but some of us have the moral fiber to resist. If Dukakis doesn't take the moral blame for her "sins and nasty habits," other people, seeing her get away it, might start drinking household products—*and getting away with it.*

"Support groups and self-help books have become a thriving business." That's *terrible.* Whatever happened to the best-sellers of old, *Go to Hell in Your Own Way and I'll Go to Hell in Mine*?

It's true that a startling variety of human behaviors, including

doing things for others ("the doormat syndrome"), is now being labeled addiction. We have love addicts, work addicts, Messies Anonymous and a magazine called *Lifeline America!* that's just about addictions. Support groups fill stadiums. Marion Barry tearfully announces he has "weaknesses."

Maybe it *has* got a little out of hand. Every disease is a problem, but not every problem is a disease.

But it doesn't make sense to dismiss suffering because it happens on a large scale, and it's probably not a good idea to revert to the atavistic, drown-the-witches habit of calling other people's behavior toward themselves "sins." We're supposed to be making progress here.

Dowd and others like her seem to fear that pretty soon everything will be excusable. We'll all start seeing ourselves as helpless and sick, not responsible for what we do. The sickest among us will get best-sellers out of it.

I don't know about that. Talking about addictions, getting help with them, isn't the same as declaiming all responsibility for them. It seems brave to me. If the talk bores other people—Dowd remarks snippily that Dukakis "speaks in the argot of addiction chic"—they can leave the room.

People are getting free. The day may even come when we can overcome one of the oldest addictions of all: the temptation to make judgments about other people.

How do you know you have it? If you find yourself moralizing a lot, even in the middle of book reviews, and you can't seem to stop, then it's probably an addiction.

Using willpower alone may not be enough to curb this compulsive behavior. A support group—Moralizers Anonymous—could probably help fill the void that drives you to it. In the meantime, as with everything else, you just have to do it one step at a time.

Tell yourself, "Just for today, I won't make things that much harder for everyone by making moral judgments."

▾ ▾ ▾

A Boy and the Sea;
a Girl and the News

There is a painting by Pieter Brueghel in which a farmer tranquilly plows a field, while in the distance, unnoticed, a boy falls into the sea and drowns. It's Icarus, who flew too close to the sun.

I feel, often, as if I'm that farmer, and world news is that boy falling into the sea. I rarely notice what's going on, and when I do it's too late.

Let me give you an appalling example. I was having a drink with a friend named Ed who makes jokes all the time. The waitress said, "How is everything?" and my friend said, "I'm worried about events in Kuwait." I laughed, and decided the next time a waitress asked me how everything was I'd say I was worried about events in Tortola, or some even more obscure place.

But when I laughed, Ed said, "I really *am* worried about Kuwait."

It was the day after the invasion. I'm embarrassed, remembering that moment now, especially because it's far from the first time the march of history has caught me with my back turned. I watch reruns of "Cheers" at 6 instead of the news, turn to Herb Caen before I read the front page, listen to Weird Al tapes instead of tuning in worried ex-admirals on KQED-FM.

Usually, I get away with it. Most news blows over in a day or two. This time, though, the background noise grew louder. Kuwait filled the air. American soldiers climbed aboard transport planes, desert camouflage started selling briskly in the surplus stores, gas prices rose. I couldn't press my thumb into a cantaloupe at Safeway

162

without overhearing men in green aprons arguing about assassinating Hussein.

The splash drew closer. Last week my sister Connie called to say that her son Jamie, who's stationed in Germany with his wife and baby, might be sent to the Middle East. Jamie is 20 years old, a baby himself. He's scared.

I feel, as I have often and with good reason felt in my life, chastened by my own ignorance.

I stopped watching TV news entirely several years back, when that awful mudslide in Pacifica killed three children. For two days every channel was showing the little caskets.

"How do you feel?" the reporters asked, shoving their mikes into the parents' faces. Sickened, I turned the news off, for the rest of the evening and for several years. At parties, I learned to just shut up and sip my wine until the conversation moved onto a topic I knew something about.

Eventually, I had to switch it back on because I'm in the media myself, and real news is mixed in there somewhere with the time-wasting cute animal stories and the Madonna tour.

But I always turned it off again. Like the farmer whose shepherd has cried wolf too many times, I have gone running too many times. The TV news calls equally loudly when Zsa Zsa Gabor has slapped a cop or the Trumps are splitting up or when America is on the brink of war.

Now when there's a genuine crisis, and the media are doing a superb job of covering it, they had taught me too well not to pay attention. Like a kid who's been dozing in the back of the classroom and is jostled awake to find the teacher asking him a question, I have to fake it, pretend I know what's going on.

Maybe pretending is as much as we can do, considering how much time it takes from our busy lives to filter the real news from the nonsense, fear-mongering and hearse-chasing that fill the air waves.

That doesn't help me with my guilt at ignoring the news, or at being caught placidly plowing my field while a boy falls unnoticed into the sea.

▼ ▼ ▼

The Five Stages of War Grief

You probably read about the terrible accident at the ant colony in Washington, D.C. The ants were trying to transfer their queen from one place to another when the hole they were trying to pull her through proved too small, and her head popped off.

Not one ant noticed. The workers are still tending their queen. They're even taking care of her head, which is believed to be somewhere in the nest. As the guy who wrote the piece said, "As Elizabeth Kubler-Ross would put it, the ants seem to be in the denial stage."

The queen continued to lay eggs for days after her head left her shoulders. Among ants, the writer noted, heads are overrated as body parts.

I cling to stories like this. Ants are always doing everything right, and it's nice to see them mess up for a change—and mess up big.

Of course, humans make mistakes and keep right on going, too. We don't know when to stop, either.

As far as this war is concerned, I am still working through Kubler-Ross' five stages myself. I'm over my denial—my blithe conviction that there wouldn't really be a war—and my initial anger that things were allowed to go this far. Bargaining came next: My proposal was that if we really had to attack, because we said we would, we should attack somewhere else, maybe Grenada, so no one gets hurt.

Then a friend called to say, somberly, "They sent the bombers in." I turned on CNN, watched in horror, turned it off, turned it

back on. This went on for days. I couldn't get anything done. I envied the cat, lying unconcerned in one of my tennis shoes with his head in another. I had reached the depression stage.

My country, right or wrong. Sometimes I wish I could be one of those people whose hearts swell when they hear that phrase, or when they see an American flag rippling in the breeze. I'd like to be at a town banquet somewhere in Iowa, where the sons are leaving for the war, and everybody makes speeches over the potato salad, and says, "Give 'em hell, son. Make me proud," and then they turn away to hide their tears.

It must feel good, and clean, and American.

Or else I'd like to feel what my daughter, Morgan, 12, is feeling. She draws peace symbols in green felt pen all over her face and yelled at the president all through the speech he made right after the first bombing.

We watched CNN for a while that first night, then got our jackets and spilled into the warm street. Morgan showed me how to make a peace sign—me, who went to high school in the '60s—and exuberantly chanted, "Out of your houses and into the streets!"

This is all new to her. It's her first war. We had to ground her last Tuesday for disappearing into the city to go help blockade the Bay Bridge. Then she called at 4:30 p.m. from Sixth and Mission to say she wanted to go on to the rally in the Mission. "They're counting on me," she pleaded.

She's honest. "A little part of me is glad for this war," she said as we walked home. "I never felt anything this strongly before."

To me, who can feel neither patriotic fervor nor the excitement of one's first peace rally, but only overwhelming sadness, this just feels familiar, and depressing. Didn't we just do this? "They shouldn't put these wars so close together," someone said. "People remember."

I don't think I'll ever get to the acceptance stage.

The only thought that comforts me, as I huddle with my children to watch my second war on television, is that among heads of state, too, heads are overrated as body parts.

Speaking Freely about Abortion

B ill and I were sitting on a bench outside the San Francisco Coffee
Company on 24th Street, drinking our lattes and reading the
paper. I hadn't been following the whole abortion thing very closely,
but that wasn't the reason I was having trouble understanding it.

"I don't get it," I said. "What does it mean, that family planning
clinics can't mention abortion to their clients? I thought abortion
was legal."

"It is," he said. Bill is a voracious newspaper reader: He knows
everything.

"Then why can't they mention it?"

"Because they get federal money. The Supreme Court ruled
that the government is entitled to decide what it wants to spend its
money on, and that its decision to forbid federally funded family
planning clinics from speaking freely about abortion doesn't violate
free speech."

"You can get an abortion legally, but it's illegal to be told about
them?"

"Right."

The sidewalk was crowded with young couples—and not-so-
young couples—and their babies. Next to us, a father trapped a gig-
gling toddler in the circle of his feet.

I turned back to the article, feeling sad.

Simon says to take a big step backward.

I knew a Marin County high school girl who got pregnant
when she was 17. I remember how scared she was when she discov-

ered, after a visit to the doctor, that Johnny had sneaked up the back steps to her room once too often.

She stood in the bright sun of the doctor's parking lot, too dazed to get into the car right away. What was she going to do? Have the baby and then give it up? She knew she didn't have that kind of courage.

She wasn't even seeing Johnny anymore, but she decided she'd marry him—that's what she'd do. He was 17 and had a good job as a box boy at a grocery store. She could probably keep working at the Orange Julius for a while, then get baby-sitting jobs. They could live with his mother.

Johnny would have to forget about engineering school, of course. She thought maybe she could finish high school, if she could endure walking around the school pregnant, but college and her hopes for a career in journalism were on hold, maybe permanently.

Johnny and she sat out in his car and talked about it, bleakly, not looking at each other. Then they began asking around about illegal abortions. People said you could get them in Tijuana.

Then it happened. Just as her choices—and his—had narrowed to a teenage marriage or a back-alley abortion, a family friend told her about a new law just passed.

If you knew how to do it, you could get a legal abortion in Marin County in 1969. All you had to do was convince three sympathetic shrinks that you were unhinged enough by the pregnancy to present a danger to yourself.

And that was it. She checked into Ross Valley Hospital, and by the next morning it was over. She had her life back. She and Johnny parted with relief, and she went back to school, happy to put to rest the ridiculous rumor that Adair Daly, who never did anything wrong, had got herself knocked up.

I thought of that story as I sat in the sun, 22 years later, still grateful to that friend who gave me information that changed my life, and read with growing sadness about a new ruling that insists, under penalty of law, that the flow of information from those who have it to those who need it must stop.

▼ ▼ ▼

About That Column on Abortion

L ast week I mentioned that I had a legal abortion in 1969. "You're going to get a lot of hate mail," Bill said when he read it. "I hope you're ready for it."

Well, I was ready for it, but I wasn't looking forward to it. I've never particularly liked people to yell at me. I once burst into tears when an irate shopkeeper told me to get that bike out of his store.

I got a lot of calls the day the column came out, but they were all warmly supportive, like the one from a retired high school counselor who said he used to stick his neck out and help girls in trouble find safe abortions long before they were legal.

When I saw the large pile of letters – 30 or so – waiting for me the next day, I figured that was the avalanche of hate mail. I had to go get a cup of coffee first to brace myself for the yelling.

Then I poked through the stack gingerly, a little surprised to note that almost all the letters had return addresses. Writers of venomous letters often leave their envelopes blank, I guess in case I get weepy and show up on their doorsteps, asking why they wanted to hurt my feelings like that.

As I started to read, I noticed that many of the readers were worried about the same thing Bill was. Joan Frank said, "Please don't let the inevitable barrage of apoplectic repressives, religious nuts and hate mail get to you."

I kept reading. I was determined not to let them get to me, but as far as I could tell they were having trouble finding my address. None of the letters that came the first day was negative, and only

three of the 26 that arrived Monday were. Either the number of pro-lifers has been wildly exaggerated or something about a personal story disarms them.

I wish I could share all these letters. A 70-year-old woman said, "I feel very strongly that anyone who tells a woman that she cannot do what is best for her particular case should be willing to take care of the resulting child for the rest of its life."

A woman from Paradise wrote, "It is my fervent hope that you won't regret your decision to reveal this very personal and private part of your life. So many of us have dug deep holes for these memories, and I know it might have been difficult to write about it so publicly."

And a man said, "One afternoon at her kitchen table, my friend told my wife and myself what she had done to obtain the illegal abortion of her third pregnancy. At the time, I foolishly thought she was confessing to us. Only years later, I realized that she had been bravely, carefully and lovingly providing us with a valuable piece of information that we might someday need. That information was not so much that abortions were possible, or how to obtain one, but that a decent and honorable woman might choose to have an abortion."

That was the other thing that struck me. Many of the letters commended me for confessing that I had had an abortion.

I appreciated those letters deeply, but I didn't confess I had an abortion.

I have confessed that I let a raccoon snatch a turtle off our porch last year. I confessed that Morgan locked me out of the house and is still not in a Swiss boarding school. I confessed that I dye my hair, something I would actually have preferred that you not know. (In fact I'd like you all to put it out of your minds, starting now. My hair has always been this vivid, natural blond.)

But I didn't confess that I had an abortion. An abortion is never easy, but they are every woman's right. There is nothing to confess.

I mentioned it.

THE HOME FRONT

▾ ▾ ▾

"My landlord, with the blood of the owners singing in his veins, is trying to do as little as he can, while I, obeying the ancient law of the tenant, am trying to get away with as much as possible.

▼ ▼ ▼

True Love
and the Art of Housekeeping

I don't know where this myth comes from, that women are neat
and tidy and men are slobs. The men I have known have been, by
and large, a fairly prissy bunch, prone to utter such inanities as, "If
a thing is worth doing, it's worth doing well."

If it's worth doing well, it's probably a waste of time. I say put
off what you can, buy cookies to match the rug, and lie in bed and
kiss a lot. You can't go wrong.

You can't go wrong, but you can end up alone this way, if you
team up with someone who hates walking on crumbs. But when
you fall in love, you shrug off such details. Both of you will change.
You will be neater, he will be taller. Love will find a way.

Take Nick, for example. He lived right next door to me, and
pretty soon we fell in love—that is, I told him that he would do until
someone else came along, and he told me how far from his usual
physical type I was, and how interesting that was for him.

With a passion like this, you ignore signs of discord. I used to
treasure the memory of how Nick came over after our first night
together, silently handed me the earrings I had left on the floor
beside the tousled bed, and gone back home.

It wasn't until much later I realized this was Nick's way of saying
that I'd left a mess in his bedroom.

But we tried to overcome these differences when we moved in
together. I tried to straighten things up whenever I could, and he
tried leaving glasses unwashed for minutes at a time. If he did notice
that I liked to run the heat full blast and then open the windows to
get a breeze, he said nothing.

▼ ▼ ▼

Gradually, though, we felt comfortable enough to let our true natures emerge. Nick sprinted in to turn off the light whenever I left the living room. I blew up potatoes in the microwave, turned off the stereo without lowering the sound first, sorted the laundry by whose it was rather than by color.

Nick remained outwardly calm. Then one morning I noticed him staring at me. "Are you going to throw rubber bands on the floor every day for the rest of our lives?" he asked.

Looking at him, I thought: This is what leads people to shoot up shopping malls. One rubber band too many.

Many nights found him bending over the dishwasher, restacking all the dishes I had put in. "The water can't get to them if you put them on top of each other," he explained, not noticing that I was searching through the flatware for something to kill him with.

I even grilled Nick's mother about his compulsive housekeeping. "Did you do this to him?" I asked. "No," she said, "it was his father." Nick didn't have to ask my mother anything, as the first time he met her she was setting a coffee mug down in his potted palm.

It started not working. I thought if he loved me he would care that it upset me to watch him restack dishes I had just stacked. He thought if I loved him I would not drive him crazy by stacking them that way in the first place. We couldn't separate love and housekeeping.

We were trying hard, though. He would put his arms around me and say, "Do you think I could ask you to turn the bathroom faucets all the way off?" and then clasp both my hands to add, "Was that all right, the way I said that?"

I got him a black T-shirt with "Don't Sweat the Small Stuff" printed on it.

He ironed it.

Who Gets Custody of the Newts?

M y ex-husband, Jim, and I agree about most things, but he put his foot down when it came to keeping the newts at his place. He argued that they should live with me and visit him on holidays, but I didn't see why the newts couldn't just go back and forth between our two houses on a regular schedule, like the kids.

Newts are, for those of you fortunate enough not to have any, little water creatures that look as if a toddler drew them with a brown crayon. Our kids got them from the creepy-crawly store on Clement Street for $1.99 each, gave them names longer than they are, and made an elaborate newt condo and tiny newt landscaping for them out of my salad spinner and some rocks from the yard.

I was willing to give the newts as much quality time as I would any other damp amphibian whose gravel was always being washed in my kitchen sink, but I was also loath to deprive them of the chance to live in Jim's restored Victorian and hear classical music 3½ days a week.

Besides, I had no idea what newts ate. I can't imagine anything lower on the food chain.

It isn't as if the commute would be a problem. Jim lives right next door, with only a high wooden fence and an overgrown back yard separating his house from my apartment building.

Come on now—don't raise your eyebrows at me like that, as if you know a lot of things I'm not telling you. It just worked out that way.

OK, since we're on the subject, I'll admit that from the outside such an arrangement might look peculiar. Jim and I are supposed to

be slicing up each other's tires, not dropping over to look for lost math books and borrowing hedge trimmers and newt accessories.

They say fewer than 10 percent of couples get along well enough to make joint custody work. We are either having trouble getting in touch with our anger, or we are just plain lucky.

He was my English teacher back at College of Marin. In my first paper I wrote, "This story revolves around Regency Park in London." He scrawled above that, "I hate revolving fiction, don't you?"

That was hard to resist. In time, we got married, and he flirted with babies over my shoulder in coffee shops. We had our own, now 10 and 11, a lot else happened, and now our increasingly complex story revolves around them.

After six years of separation, I still try to impress the kids with how lucky they are, having both parents so near when their friends' fathers live in L.A. or New York. They don't feel especially lucky, but they're getting closer to accepting it now. Another couple of hundred years should do it.

There's much their dad and I find hard to talk about now, but there's still a lot we can share, too. He has a small press now. I think I can claim some small role in his success because he listens carefully to my opinion on book projects, then makes a killing by doing exactly the opposite.

"Nobody wants to read about Mount Tamalpais," I inform him with great conviction, so of course he sells out his entire first printing in two weeks.

In the end Jim found a spot in the kitchen for the newts. If he didn't, he wouldn't be Jim. He even drove back to the creepy-crawly store to get the mealworms it turns out they eat. I called over there a while ago, and he said, sounding hopeful, "One of the newts is dead. It fell on the floor."

But it wasn't dead. It had only fainted, probably with joy at escaping the rock music at my house.

Now Jim asks, genuinely puzzled, "What am I supposed to feed the mealworms?"

Turtle on the Lam

I didn't mean to lose the turtle. It's just that since Neil and I had this fight, I've had to work brooding into an already crowded schedule, and I completely forgot that I put the turtle in the yard.

We just got him last weekend. Seventy bucks for one five-inch turtle with accessories, including a glass aquarium and a dozen feeder goldfish. Despite this largess, the turtle seemed depressed and was spending all day staring moodily through the glass.

Thinking a little constitutional would cheer him up, I plopped him down by the rosebush and went in the house to vacuum the ants out of the freezer and run a speculative finger across the topsoil on the Venetian blinds. Then it was time to brood about Neil for a while. By the time I remembered Todd – short for Todd Turtle – and raced outside, he was gone – a lean, green escaping machine.

I don't think he was justified in taking off. There should be such a thing as commitment, even for turtles. Besides, I liked the little guy. The kids had fallen in love with his fish dinners, giving them names like Spud and Tiny and putting them in cereal bowls, but I had bonded with Todd. He was slow in more ways than one – in a classroom where the seating is by IQ, turtles would sit right in front of salamanders – but he reminded me of Neil. Maybe it was the way he would go into his shell sometimes. At least in Todd's case you could see him doing it – you just glanced over to see if his head was there or not.

Besides, I have money invested here. Todd is worth $15 on the – what? Not hoof. What are turtle feet called? Hold on, I'll look it up. A little turtle research might take my mind off Neil. Patrick

asked whether the turtle came with instructions (city kid), so I got this book called *Turtles*.

Here it is. How to operate your turtle. But there's nothing on what turtle feet are called.

Wait, here's something else. "Turtles do not pair for life or even for a season. A male finds a female who acts or looks or smells right and he rubs her face with his long claws or bites her legs, and eventually she may become receptive."

"Acts or looks or smells right"? He just nibbles her feet, whatever the hell they're called, and she melts? I had no idea girl turtles were this shallow.

This is working. I have pretty much forgotten about what's his name. Still perplexed about Todd, though. Might have to get a plaque out there, dedicated to the Old Turtle, whose fate we shall never know. "He just marched off one morning, without a word to anyone, and the waters of history closed over his little green head." Either that or he's hiding in the ivy by the brick wall, congratulating himself on his cleverness and planning the next stage, a sprint into the Nakamuras' yard.

He would do better to just come on back. I can't offer him a goldfish—they are all swimming around in my dinnerware—but we do have that great staple of turtle cuisine, Tetra Repto Min Floating Food Sticks. Todd is the same bilious green as every plant in my garden, and so stands a good chance of being discarded by the teenager who's coming over in a little while to pull weeds. Even the Old Gringo didn't have to go out to face his maker in a brown plastic bag with bits of hedge and rosemary.

Could be worse, though. Listen to this: "If your turtle is sick and past saving, the humane way to kill it is to seal it in a plastic bag and put it in the freezer."

I can just see this. Neil comes over, begging forgiveness for momentarily forgetting how wonderful I am. I manage to pluck his name out of the air and offer to make him dinner. "Honey, what do you feel like eating?" I'll ask.

"Oh, I don't know," he'll say. "Why don't you defrost something?"

Nothing's an Accident
in Interior Design

I have begun to think I should do something with my place. It's a rental, and all we did is move in, set everything down and start arguing about TV programs. I'd like to fix it up a little, so the kids and I can entertain our friends—on purpose, for a change, instead of when we don't know we're doing it.

I don't know the first thing about interior design, and neither do the kids—or at least I didn't think we did. Lately I've been leafing through house magazines for ideas, and I'm pleased to learn we have an unconscious flair for this sort of thing.

For example, the editor of *French Vogue,* like me, never redoes an apartment. "It is more challenging," she informs us, "to impose my taste within a set of limitations."

So true. Although my own limitations—lack of money, lack of time, lack of taste, lack of interest—are probably more challenging than hers, I think the kids and I have managed to impose our taste on the place despite them.

Patrick's room, for example, illuminates Herbert Muschamp's meaning when he said in *HG,* "We want a place for everything, but not necessarily everything in its place."

Nothing is in its place in Patrick's room. The shoes spilling sand on the bed, the quilt flowing to the linoleum, the cereal dish in the sock drawer—all sum up the relaxed aesthetic of the on-the-go 9-year-old.

In his sister Morgan's room the look is even more unspoiled— the bed unmade, all the drawers pulled out and clothes, some of

them looking suspiciously like mine, flooding the floor and eddying over the lamps and bookshelves. This is clothing used as art, a leading trend in house magazines. Morgan, reclining on a pile of laundry, is taking it even one step further—clothing used as furniture.

It's uncanny. One designer might almost have had the three bikes blocking our hallway in mind when he described his own deliberately cramped apartment. "The space is impossible to walk casually through," he said. "You take notice of things when you must step aside, walk cautiously and glance back."

I eagerly read on. In another magazine, a designer invites visitors to observe how, in his dazzling million-dollar apartment, "found, discarded and mundane things share weight and importance with art objects."

This is welcome news. The found, the mundane and the discarded account for such a substantial part of my furnishings that they have crowded out the art objects altogether. This doesn't matter. It's clear from my reading that you don't need art, or even taste, if you make a bold enough statement.

After all it was in *HG,* again, that an essayist quoted Baudelaire. "What is intoxicating about bad taste," he said, "is the aristocratic pleasure of not pleasing."

This pleasure can be had in every corner of our apartment, from the sinking mauve couch in the living room to the upended picnic cooler serving as a fourth chair in the kitchen. The cooler doesn't belong there, which means it breaks aesthetic ground, as does the car fender one designer keeps in his living room.

People in design magazines leave a lot of stuff on the floor—paintings, pre-Columbian urns, Christmas lights flung in corners in July. This is to "draw the eye downward." We've been doing this for years, using mainly skateboards and Lego parts, but sometimes adding jackets, Popsicle wrappers and fallen Christmas ornaments, depending on the season.

In the end, I put the house magazines away. There seems to be nothing we can learn from them.

He's Not Perfect, but He's Mine

"**I** don't understand women," a man in a *New Yorker* cartoon says to another guy in a bar. "But I got me one."

I know the feeling. I don't understand cats, either, but I got me one. A kitten named Mike who just sank a fang into my thumb when I interrupted him as he was enjoying some cake on the table. When I yelled, he did his Robert De Niro impersonation. "You talking to me? *You* talking to *me*?"

He bites. He springs from nowhere to land on my shoulder, then slides slowly back, clawing my back desperately. He climbs right back up my clothes, if I'm lucky enough to be dressed. He walks all over me, and I let him.

I don't get it. I read all the right books, including *Women Who Love Cats and the Cats Who Claw Them,* and that new one, *How to Fall in Love With a Nice Cat.*

When I found Mike, it all went right out of my head. It was a pet shop in San Rafael, about three months ago. I was just browsing, killing time. It isn't as if I need a cat. An independent woman like myself.

There were lots of other kittens there, nice kittens, rubbing against their cages, not afraid to let their feelings show. Tiger stripes, fluffy grays. But of course I let my glance slide right to Mike, a gray-eyed, smoky-eared little good-for-nothing scowling and biting the wire of his cage.

As soon as we got home, he disappeared under the bed for the rest of the day, leading me to consider going into therapy to find out why I always fall for unavailable cats.

180

When he came out, it was to pull out the computer plug, jump on the keyboard to put in lines of w's, bite the printer, hide my pens under the couch and otherwise express skepticism about what I do for a living.

But if I must work, he has decided, I should be up and at it early. Every morning at 6, little paws slide under the door, accompanied by a soft mewing that will turn to eyebrow biting if I let him in.

Therapy for me? Mike's the one with the problem. One of us will have to change, all right, but it isn't going to be me.

I got some ideas when a guy on CNN was flogging a book with the preposterous title, *How to Get Your Cat to Do What You Want.* If you leave town, author Warren Eckstein says, leave laundry around so your cat won't miss you (this trick even my kids know) and call long-distance so the cat will hear your voice on your turned-up answering machine.

I can just see this, spending three bucks a minute to yell, "Get down from there! Stop that!" Mike will pause for a split second in his dismantling of the couch, then think to himself, "Relax, man. She's *outta town.*"

To release some of that nervous energy, Eckstein suggests, "Try teaching your young cat to walk on a leash." So I took my young cat out. Although there was no actual walking, I got 10 thoroughly enjoyable minutes of watching him trying to get his new collar off, we had a demonstration of the Cat Slide up Waller Street, and when a truck went by Mike was able to practice his clawing-the-back-in-a-panic trick.

Despite such precious moments, sometimes I'm tempted to unhook Mike from what's left of the couch and say, "We have to talk. I want a cat who listens, who walks on a leash, who doesn't sleep in any lap that will have him."

But I know what Mike would be thinking, as he rakes my eyeball with an affectionate swipe of the paw. "*Cat.* I'm a *cat.* You want a dog, get a dog. If you want a cat, here I am."

I hate a smarty cat.

▼ ▼ ▼

When Your Home
Is the Landlord's Castle

My landlord and I are locked in mortal combat. He, with the blood of the owners singing in his veins, is trying to do as little as he can, while I, obeying the ancient law of the tenant, am trying to get away with as much as possible.

Sometimes the tide of battle goes his way. At these times the hallway stays dark, the toilet runs, the horrible '50s linoleum in my bedroom snaps at my heels, and the wheezing fridge has little accidents in the night that have to be wiped up in the morning. While this is happening, my landlord leads his life placidly elsewhere, buffeted from life's unpleasantness by the third of my income I mail to his house every month.

Sometimes I seem to be winning. While he's out spending my money, I stay happily at home, trying to figure how which part of the walls will take a nail by trying different places. I drag my desk heavily across the wood floor of the living room, then decide I liked it better where it was, and drag it heavily back.

I carry mountain bikes in and out, their pedals raking the walls. I keep company with men who rip smoke alarms out of the ceiling instead of just turning them off. Then I call up and complain the smoke alarm isn't working.

At night I tiptoe into two little rooms, kissing two children good night. It says on the lease I have only one. I simply miscounted; it could happen to anyone.

And now that I look around, I seem to have a cat. How did *that* get in here?

▼ ▼ ▼

182

Given these tiny irregularities, I naturally don't like to bother the landlord with my little problems. He, naturally, would prefer not to be bothered. We had been in complete harmony on this point for the 16 months of my residence.

Then the water heater lost all heart. It couldn't go on without its old friend the fridge. It started weeping brown tears, tears that became a sea in the little room it shares with Patrick.

I had to write a little note.

My landlord knows that into every landlord's life a little note must fall. He let the usual six months go by, then arrived unannounced last Saturday with a crew of workmen in a truck. One guy shouldered a roll of carpeting and headed for my room. It looked an awful lot like the flat black carpeting in the outside hall, but that was my fault. I hadn't thought to specify indoor carpeting.

When two more workmen wheeled in a new fridge, missing only a few unimportant shelves on the door and a couple of wire racks, I was so abjectly grateful that it was a minute or two before I remembered this was the *landlord*.

I gave Patrick five bucks and told him to beat it. Then I noticed Mike, the cat, licking his fur in the middle of the rug. You would have thought he lived there.

"What are you doing here?" I yelled loudly. "Shoo! Scat! Go home!"

Astonished, Mike slunk out, following Morgan as she carried out his litter box to hide it.

I thanked the landlord for my industrial carpeting and my new shelf-less refrigerator. "It was the least I could do," he said graciously.

I agreed. The very least. He had forgotten the hall light, the toilet, the water heater, and the knob that sticks on Morgan's door.

I didn't care. He hadn't noticed the cat, either. As I went out to get Mike, who was glowering at me from the fence, it occurred to me it's a shame to have this nice yard, not to mention this nice 10-year-old boy, without some sort of dog to go with them.

We'll need a pet door of course. And those hedges will have to go, and . . .

▼ ▼ ▼

Thoughts of Sex, Food and, Mostly, Nothing

T he kids and I watched that National Geographic show, the one that was a shameless ode to cats—their wisdom, their aloofness, their mystery.

We wanted to believe it, but we looked over at our cat Mike, who was watching the yard TV— the reflection of the TV in the patio door—and we had to laugh.

Mike has a brain the size of a peach pit. You can conclude that behind that baleful expression lurks a creature of aloofness and mystery, but I'm inclined to go with the person who said cats think about three things: food, sex, and nothing.

In fact in Mike's case, even that seemed like too many subjects, so I had him fixed.

He doesn't like riding in the car much, so just driving him to the shelter was an experience. By the time I got there I was wearing him around my neck, a fetching white and gray Mike scarf.

The woman in line in front of me didn't have a cat, but the sleeve of her warm-up jacket was panicking. The man holding an orange cat said, "I feel very sad having to do this." I nodded. I had dreams of letting Mike grow into a huge Tom who comes home after days away with a torn ear and a satisfied look in his good eye, while the neighborhood slowly fills with snarling, white-footed, peach-pit-brained Mikes.

When I got him back 24 hours later, he was much calmer. They brought him out to me, and you could tell for him it was now food and nothing.

I took him home, and he started rubbing his head on my

ankles. I thought he had become more affectionate until I realized he was trying to trip me so I'd land with my head next to the sink cabinet where I kept the 9-Lives.

He couldn't pick me out of a police line-up ("No, man, don't recognize her"), but aloof is not a word I'd use with Mike. I haven't had this intense a relationship since I owned a dog. He's in constant terror of being caught actually wanting to be near any of us, yet that's all he lives for.

He hurls himself against my bedroom door and then walks right past me, pretending it wasn't me he wanted at all — there was something he had to do in the bedroom. When I come home late at night, he's standing anxiously by the door, but immediately runs the other way, so no one will think he was waiting up.

Somehow Mike became convinced that I feel the same way about him, something you and I know is certainly not true. He thinks my typing is an arrested petting action, and tries to help out by stepping on the "w" key and putting his head under my hands. All day long, he tries this.

Is he mysterious? Even to himself, I'd say. Being out in the yard makes him yearn to come in, and being inside convinces him his happiness lies in being in the yard. I have to open the patio door for him 400 times a day. When I do, he freezes for a second on the threshold, and it's plain to anybody that even he can't remember whether he's coming or going.

Yet you can tell by his dignified expression that he's convinced he could never do anything silly. He curls up in the trash basket, and lies there staring unblinkingly up at me and the kids, clearly at a loss to understand what we're laughing at.

I don't know why I keep him around. He refuses to guard the house, and when he isn't throwing away a perfectly good cat — a sad display of low self-esteem — he's dumping over the trash, nosing through my balled-up scribblings to see if I took out the nice line of w's he put in.

Anybody who would like to buy a nice cawww www wwwww wwww wwww wwww . . .